Geometry of Desi[g]
Studies in Propor[t]
Second Edition, R[e]

Kimberly Elam

Princeton Architectural Press, New York

.

Published by
Princeton Architectural Press
37 East 7th Street
New York, New York 10003

Visit our web site at www.papress.com.

© 2001, 2011 Princeton Architectural Press
All rights reserved
Printed and bound in China
Second, revised and updated edition
15 14 13 5 4 3 2

No part of this book my be used or reproduced in any
manner without written permission from the publisher,
except in the context of reviews.

Every reasonable attempt has been made to identify
owners of copyright. Errors or omissions will be cor-
rected in subsequent editions.

Book design: Kimberly Elam
Editor, first edition: Jennifer Thompson
Editor, second edition: Dan Simon

Special thanks to: Bree Anne Apperley, Sara Bader,
Janet Behning, Nicola Bednarek Brower, Fannie Bushin,
Megan Carey, Carina Cha, Tom Cho, Penny (Yuen Pik)
Chu, Russell Fernandez, Jan Haux, Linda Lee,
John Myers, Katharine Myers, Margaret Rogalski,
Andrew Stepanian, Paul Wagner, Joseph Weston,
and Deb Wood of Princeton Architectural Press
—Kevin C. Lippert, publisher

Library of Congress Cataloging-in-Publication Data
Elam, Kimberly, 1951–
Geometry of design : studies in proportion and
composition / Kimberly Elam. — 2nd ed., rev. and
updated.
143 p. : ill. (some col.) ; 22 cm. — (Design briefs)
Includes bibliographical references.
ISBN 978-1-61689-036-0 (alk. paper)
1. Proportion (Art) 2. Composition (Art) 3. Golden
section. 4. Art, Modern—20th century. 5. Design—
History—20th century. I. Title.
N7431.5.E44 2011
701'.8—dc22
 2011012140

DESIGN BRIEFS—essential texts on design
Also available in this series:

Designing For Social Change, Andrew Shea
978-1-61689-047-6

D.I.Y. Design It Yourself, Ellen Lupton
978-1-56898-552-7

Elements of Design, Gail Greet Hannah
978-1-56989-329-5

Form + Code in Design, Art, and Architecture,
Casey Reas, Chandler McWilliams, LUST
978-1-56898-937-2

Graphic Design Theory, Helen Armstrong
978-1-56898-249-6

Graphic Design Thinking, Ellen Lupton
978-1-56898-979-2

Grid Systems, Kimberly Elam
978-1-56898-465-0

Lettering & Type, Bruce Willen & Nolen Strals
978-1-56898-765-1

Indie Publishing, Ellen Lupton
978-1-56898-760-6

Participate, Armstrong & Stojmirovic
978-1-61689-025-4

Thinking with Type, 2nd edition, Ellen Lupton
978-1-56898-969-3

Typographic Systems, Kimberly Elam
978-1-56898-687-6

Visual Grammar, Christian Leborg
978-1-56898-581-7

The Wayfinding Handbook, David Gibson
978-1-56898-769-9

Back cover images: Leonardo da Vinci, *Human Figure in
a Circle* courtesy *Leonardo Drawings*, Dover Publica-
tions, Inc., 1980. Pine cone photograph by Allen Novak.

Table of Contents

Introduction

Albrecht Dürer
Of the Just Shaping of Letters, 1535
"…sane judgement abhors nothing so much as a picture perpetrated with no technical knowledge, although with plenty of care and diligence. Now the sole reason why painters of this sort are not aware of their own error is that they have not learnt Geometry, without which no one can either be or become an absolute artist; but the blame for this should be laid upon their masters, who themselves are ignorant of this art."

Max Bill
Quoted from Max Bill's writing in 1949, *Typographic Communications Today*, 1989
"I am of the opinion that it is possible to develop an art largely on the basis of mathematical thinking."

Le Corbusier
Towards A New Architecture, 1931
"Geometry is the language of man.…he has discovered rhythms, rhythms apparent to the eye and clear in their relations with one another. And these rhythms are at the very root of human activities. They resound in man by an organic inevitability, the same fine inevitability which causes the *tracing out of the Golden Section* by children, old men, savages and the learned."

Josef Müller-Brockmann
The Graphic Artist and His Design Problems, 1968
"…the proportions of the formal elements and their intermediate spaces are almost always related to certain numerical progressions logically followed out."

Too often as a design professional and educator I have seen excellent conceptual ideas suffer during the process of realization, in large part because the designer did not understand the visual principles of geometric composition. These principles include an understanding of classic proportioning systems such as the golden section and root rectangles, as well as ratios and proportion, interrelationships of form, and regulating lines. This book seeks to explain visually the principles of geometric composition and offers a wide selection of professional posters, products, and buildings that are visually analyzed by these principles.

The works selected for analysis were selected because they have stood the test of time and in many respects can be considered design classics. The works are arranged in chronological order and have a relationship to the style and technology of the time as well as to the timelessness of classic design. Despite the differences in the era in which the work was created and differences in form, from small two-dimensional graphics to architectural structures, there is a remarkable similarity in the knowledgeable planning and organization through geometry.

The purpose of *Geometry of Design* is not to quantify aesthetics through geometry but rather to reveal visual relationships that have foundations in the essential qualities of life such as proportion and growth patterns as well as mathematics. Its purpose is to lend insight into the design process and give visual coherence to design through visual structure. It is through this insight that the artist or designer may find worth and value for themselves and their own work.

Kimberly Elam
Ringling College of Art and Design

Cognitive Proportion Preferences

Within the context of the man-made environment and the natural world there is a documented human cognitive preference for golden section proportions throughout recorded history. Some of the earliest evidence of the use of the golden section rectangle, with a proportion of 1:1.618, is documented in the architecture of Stonehenge built in the twentieth to sixteenth centuries, B.C.E. Further documented evidence is found in the writing, art, and architecture of the ancient Greeks in the fifth century, B.C.E. Later,

Renaissance artists and architects also studied, documented, and employed golden section proportions in remarkable works of sculpture, painting, and architecture. In addition to man-made works, golden section proportions can also be found in the natural world through human proportions and the growth patterns of many living plants, animals, and insects.

Curious about the golden section, German psychologist Gustav Fechner, late in the late nineteenth cen-

Table of Rectangle Proportion Preference

Ratio: Width/Length	Most Preferred Rectangle % Fechner	% Lalo	Least Preferred Rectangle % Fechner	% Lalo	
1:1	3.0	11.7	27.8	22.5	square
5:6	0.2	1.0	19.7	16.6	
4:5	2.0	1.3	9.4	9.1	
3:4	2.5	9.5	2.5	9.1	
7:10	7.7	5.6	1.2	2.5	
2:3	20.6	11.0	0.4	0.6	
5:8	35.0	30.3	0.0	0.0	golden section proportion
13:23	20.0	6.3	0.8	0.6	
1:2	7.5	8.0	2.5	12.5	double square
2:5	1.5	15.3	35.7	26.6	
Totals:	100.0	100.0	100.0	100.1	

1:1
square

5:6

4:5

3:4

7:10

tury, investigated the human response to the special aesthetic qualities of the golden section rectangle. Fechner's curiosity was due to the documented evidence of a cross-cultural archetypal aesthetic preference for golden section proportions.

Fechner limited his experiment to the man-made world and began by taking the measurements of thousands of rectangular objects, such as books, boxes, buildings, matchbooks, newspapers, etc. He found that the average rectangle ratio was close to a ratio known as the golden section, 1:1.618, and that the majority of people prefer a rectangle whose proportions are close to the golden section. Fechner's thorough yet casual experiments were repeated later in a more scientific manner by Charles Lalo in 1908 and still later by others, and the results were remarkably similar.

Comparison Graph of Rectangle Preference

Fechner's Graph of Best Rectangle Preference, 1876 ●
Lalo's Graph, 1908 ▨

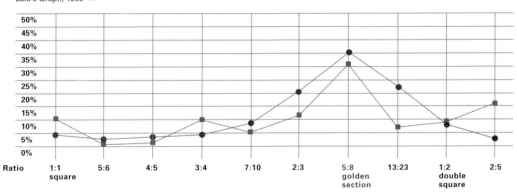

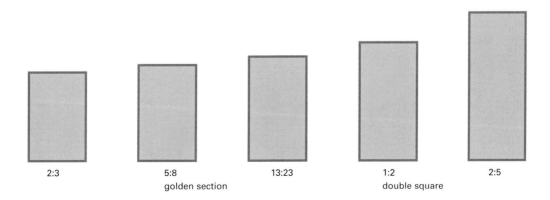

| 2:3 | 5:8
golden section | 13:23 | 1:2
double square | 2:5 |

Proportion and Nature

"The power of the golden section to create harmony arises from its unique capacity to unite different parts of a whole so that each preserves its own identity, and yet blends into the greater pattern of a single whole."

Gyӧrgy Doczi, *The Power of Limits*, 1994

Golden section preferences are not limited to human aesthetics but are also a part of the remarkable relationships between the proportions of patterns of growth in living things such as plants and animals.

The contour spiral shapes of shells reveal a cumulative pattern of growth and these growth patterns have been the subject of many scientific and artistic studies. The growth patterns of shells are logarithmic spirals of golden section proportions, and what is known as the theory of a perfect growth pattern.

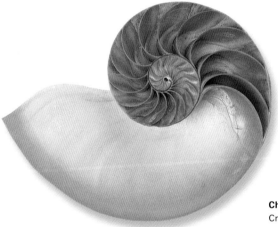

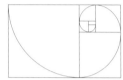

Golden Section Spiral
Construction diagram of the golden section rectangle and resulting spiral.

Chambered Nautilus
Cross section of the nautilus' spiral growth pattern

8

Atlantic Sundial Shell
Spiral growth pattern

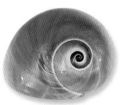

Moon Snail Shell
Spiral growth pattern

Theodore Andreas Cook, in his book *The Curves of Life,* describes these growth patterns as "the essential processes of life." In each growth phase characterized by a spiral, the new spiral is very close to the proportion of a golden section square larger than the previous one. The growth patterns of the nautilus and other shells are never exact golden section proportions. Rather, there is an attempt in biological growth pattern proportion to approach but never reach exact golden spiral proportions.

The pentagon and pentagram star also share golden section proportions and can be found in many living things such as the sand dollar. The interior subdivisions of a pentagon create a star pentagram, and the ratio of any two lines within a star pentagram is the golden section proportion of 1:1.618.

Comparison of Tibia Shell Spiral Growth Pattern and Golden Section Proportion

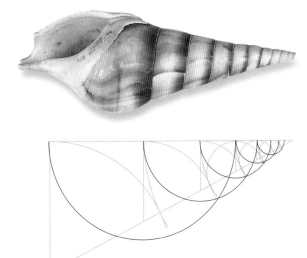

Pentagon Pattern
The pentagon and star pentagram have golden section proportions, as the ratios of the sides of the triangles in a star pentagram is 1:1.618. The same pentagon/pentagram relationships can be found in the sand dollar and in snowflakes.

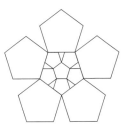
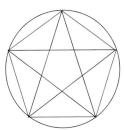

The spiral growth patterns of the pine cone and the sunflower share similar growth patterns. The seeds of each grow along two intersecting spirals which move in opposite directions, and each seed belongs to both sets of intersecting spirals. Upon examining the pine cone seed spirals, 8 of the spirals move in a clockwise direction and 13 in a counterclockwise direction, closely approximating golden section proportions. In the case of the sunflower spirals there are 21 clockwise spirals and 34 counter clockwise spirals, which again approximate golden section proportions.

The numbers 8 and 13 as found in the pine cone spiral and 21 and 34 as found in the sunflower spiral are very familiar to mathematicians. They are adjacent pairs in the mathematical sequence called the Fibonacci sequence. Each number in the sequence is determined by adding together the previous two: 0, 1, 1, 2, 3, 5, 8, 13, 21, 34,

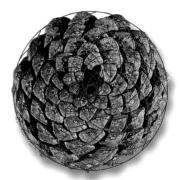

Spiral Growth Patterns of Pine Cones

Each seed in the pine cone belongs to both sets of spirals. 8 of the spirals move clockwise and 13 of the spirals move counterclockwise. The proportion of 8:13 is 1:1.625 which is very close to the golden section proportion of 1:1.618

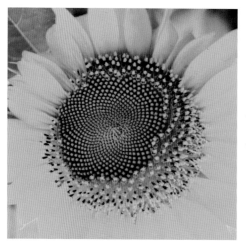

Spiral Growth Patterns of Sunflowers

Similar to the pine cone, each seed in the sunflower belongs to both sets of spirals. 21 spirals move clockwise, and 34 spirals move counterclockwise. The proportion of 21:34 is 1:1.619 which is very close to the golden section proportion of 1:1.618

55....The ratio of adjacent numbers in the sequence progressively approaches golden section proportions of 1:1.618.

Many fish also share relationships with the golden section. Three golden section construction diagrams placed on the body of the rainbow trout show the relationships of the eye and the tail fin in the reciprocal golden rectangles and square. Further, the individual fins also have golden sec-

tion proportions. The blue angle tropical fish fits perfectly into a golden section rectangle and the mouth and gills are on the reciprocal golden section point of the body's height.

Perhaps a part of our human fascination with the natural environment and living things such as shells, flowers, and fish is due to our subconscious preference for golden section proportions, shapes, and patterns.

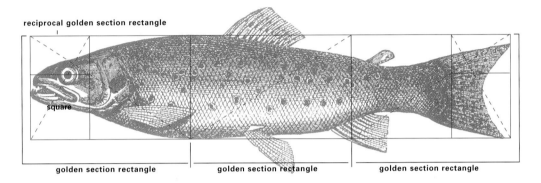

reciprocal golden section rectangle

square

golden section rectangle golden section rectangle golden section rectangle

Golden Section Analysis of a Trout
The body of the trout is enclosed by three golden section rectangles. The eye is at the level of the reciprocal golden rectangle and the tail fin is defined by a reciprocal golden rectangle.

Golden Section Analysis of a Blue Angle Fish
The entire body of the fish fits into a golden section rectangle. The mouth and gill position is at the reciprocal golden section rectangle.

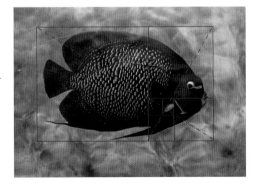

Human Body Proportions in Classical Sculpture

Just as many plants and animals share golden section proportions, humans do as well. Perhaps another reason for the cognitive preference for golden section proportions is that the human face and body share the similar mathematical proportional relationships found in all living things.

Some of the earliest surviving written investigations into human proportion and architecture are in the writings of the ancient Roman scholar and architect Marcus Vitruvius Pollio, who is widely referred to as Vitruvius. Vitruvius advised that the architecture of temples should be based on the likeness of the perfectly proportioned human body where a harmony

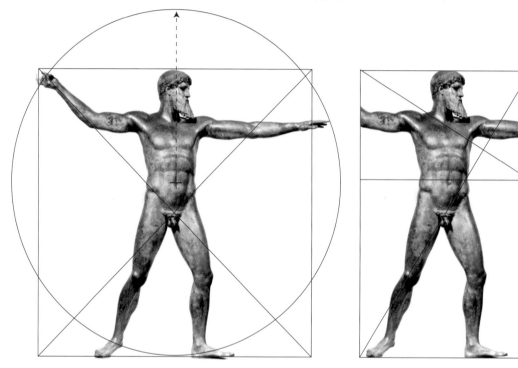

12

***Poseidon* Analyzed According to Vitruvius's Canon**
A square encloses the body while the hands and feet touch a circle with the navel as center. The figure is divided in half at the groin, and (right) by the golden section at the navel.

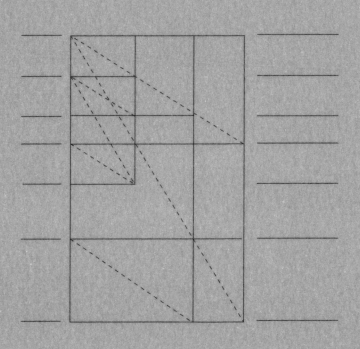

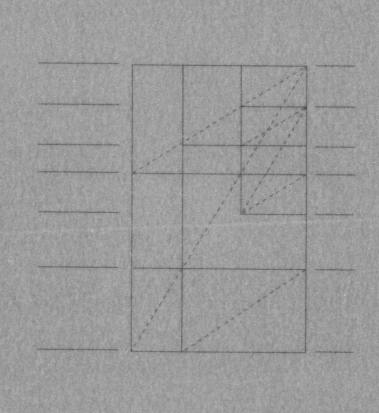

exists among all parts. Vitruvius described this proportion and explained that the height of a well proportioned man is equal to the length of his outstretched arms. The body height and length of the outstretched arms create a square that enclose the human body, while the hands and feet touch a circle with the navel as the center. Within this system the human form is divided in half at the groin, and by the golden section at the navel. The statues of the *Spear Bearer* and *Poseidon* are both from the fifth century B.C.E. Although created by different sculptors, the proportions of the *Spear Bearer* and *Poseidon* are both clearly based on the canon of Vitruvius and the analysis of the proportions used is almost identical.

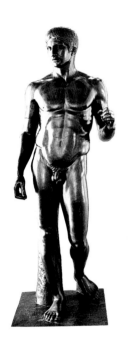

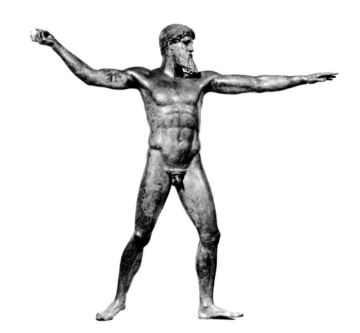

13

Doryphoros, the Spear Bearer

Poseidon of Artemision

Golden Section Proportions of Greek Sculpture
Each golden section rectangle is represented by a rectangle with a dashed diagonal line. Multiple golden section rectangles share the dashed diagonal. The proportions of the two figures are almost identical.

Human Body Proportions in Classical Drawing

Vitruvius's canon, was also used by Renaissance artists Leonardo da Vinci and Albrecht Dürer in the late fifteenth and early sixteenth centuries. Both da Vinci and Dürer were students and scholars of proportioning systems of the human form. Dürer experimented with a number of proportioning systems that were illustrated in his *Four Books on Human Proportion* (1528). Da Vinci illustrated the mathematician Luca Pacioli's book, *Divina Proportione* (1509).

Individually, both da Vinci's and Dürer's drawings clearly conform to the proportioning system of Vitruvius. Further, an overlay comparison of da Vinci's and Dürer's proportion drawings reveals that the body proportions in both drawings share the proportions of Vitruvius and that the two are almost identical. The only significant difference is in the facial proportions.

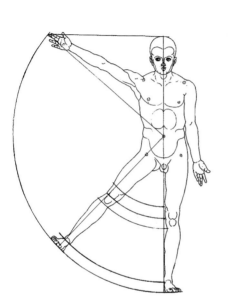

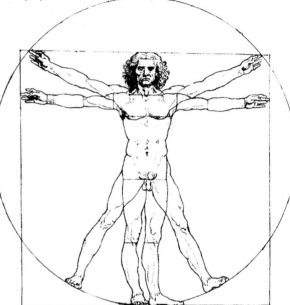

Man Inscribed in a Circle, **Albrecht Dürer, after 1521**

Human Figure in a Circle, Illustrating Proportions, **Leonardo da Vinci, 1485–1490**

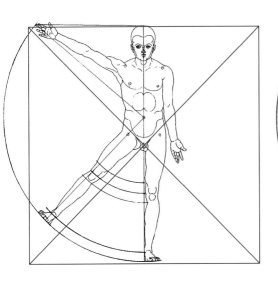

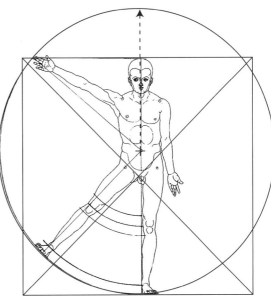

Vitruvius's Canon Applied to Dürer's Drawing of
Man Inscribed in a Circle
A square encloses the body while the hands and
feet touch a circle with the navel as center. The fig-
ure is divided in half at the groin, and by the golden
section at the navel.

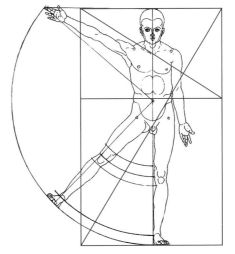

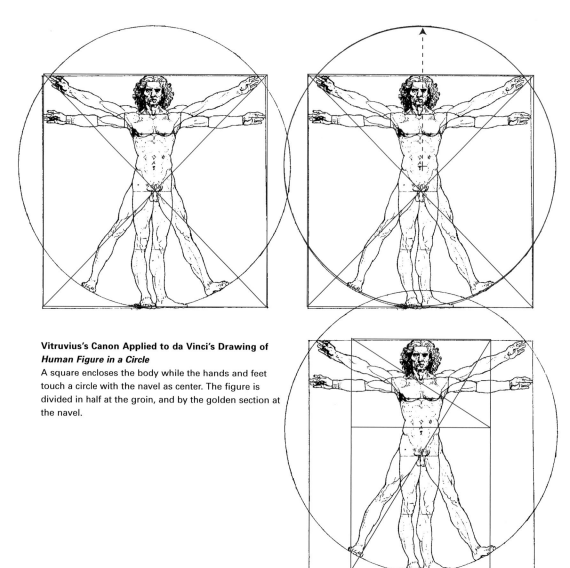

Vitruvius's Canon Applied to da Vinci's Drawing of
Human Figure in a Circle
A square encloses the body while the hands and feet
touch a circle with the navel as center. The figure is
divided in half at the groin, and by the golden section at
the navel.

Comparison of the Proportions of Dürer (red) and da Vinci (black)
The proportions of Dürer and da Vinci are almost identical. Both drawings follow Vitruvius's Canon although they were drawn at different times and in different places.

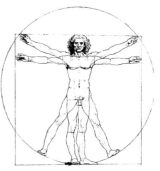

Albrecht Dürer, *Man Inscribed in a Circle*

Leonardo da Vinci, *Human Figure in a Circle*

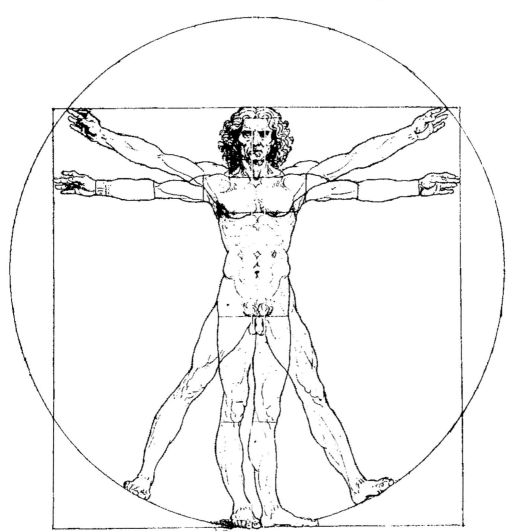

17

Facial Proportions

The canon of Vitruvius includes human facial proportions as well as body proportions. The placement of the facial features yields the classic proportions used in Greek and Roman sculpture.

While both Leonardo da Vinci and Albrecht Dürer employed Vitruvius's canon of body proportions, dramatic differences exist in the facial proportions. Da Vinci's system for the face mirrors that of Vitruvius

and faint construction lines can be seen in his original drawing of human proportions.

Dürer, however, uses distinctly different facial proportions. Dürer's facial proportions in his *Man Inscribed in a Circle* drawing are characterized by low set facial features and a high forehead, which is possibly an aesthetic preference of the fashion of the time. The face is divided in half by a line at the top of the eye

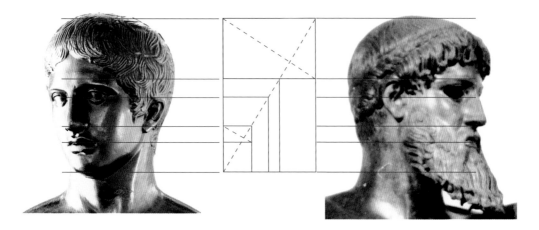

Comparison of Facial Proportions and the Golden Section
Detail of the head of *Doryphoros, the Spear Bearer* (left). Detail of the head of the *Poseidon of Artemision* (right). Facial proportion analysis is according to Vitruvius's canon, and the proportions are almost identical. The diagram shows a single golden section rectangle as the guide for the length and width of the head. This golden rectangle is further subdivided by smaller golden section rectangles to determine the placement of the features.

Dürer's Facial Proportion Studies
Four samples from *Four Constructed Heads, Studies in Physiognomy*, about 1526–27

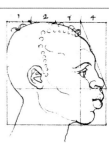

brows, with the features of eyes, nose, and mouth below this line, and shortened neck. The same facial proportions are repeatedly used throughout many drawings in the book *Four Books on Human Proportion*, 1528. Dürer also experiments with facial proportion in the drawing *Four Constructed Heads*, in which he introduces oblique lines into the construction grid to produce variations.

Humans like other living things very rarely attain perfect golden section, facial or body proportions, except through the artist's vision in drawing, painting, and sculpture. The use of golden section proportions by artists, particularly the ancient Greeks, was an attempt to idealize and systemize the representation of the human body.

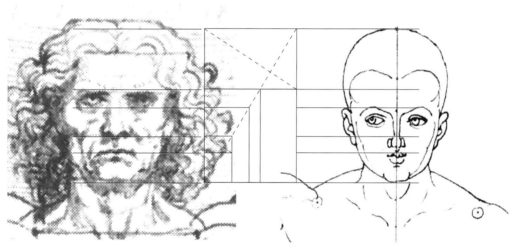

Comparison of Facial Proportions of Drawings by da Vinci and Dürer
Detail of the head of da Vinci's *Human Figure in a Circle* (left), and a detail of the head of Dürer's drawing of *Man Inscribed in a Circle* (right). Da Vinci's facial proportions match Vitruvius's Canon, whereas Dürer's facial proportions are distinctly different.

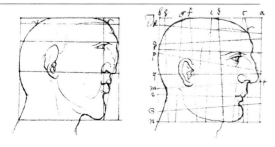

Architectural Proportions

In addition to documenting human body proportions, Vitruvius was also an architect who documented harmonious architectural proportions. He advocated that the architecture of temples should be based on the perfectly proportioned human body where there exists a harmony between all parts. He is credited with introducing the concept of the module, in the same way as the human proportions were expressed in a module representing the length of the head or feet. This concept became an important idea throughout the history of architecture.

The Parthenon in Athens is an example of the Greek system of proportioning. In a simple analysis the facade of the Parthenon is embraced by a subdivided golden rectangle. A reciprocal rectangle forms the height of the architrave, frieze, and pediment. The square of the main rectangle gives the height of the pediment, and the smallest rectangle in the diagram yields the placement of the frieze and architrave.

Centuries later the "divine proportion," or golden section, was consciously employed in the architec-

Drawing of the Parthenon, Athens, ca. 447–432 B.C.E., and the Architectural Relationship to the Golden Section
Analysis of golden section proportions according to the golden section construction diagram

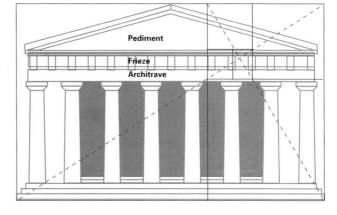

Golden Section Harmonic Analysis
Analysis of golden section proportions according to a diagram of a harmonic analysis of the golden section

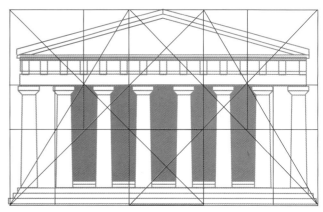

ture of Gothic cathedrals. In *Towards A New Architecture*, Le Corbusier cited the role of the square and the circle in the proportions of the facade of the Cathedral of Notre Dame, Paris. The rectangle around the cathedral facade is in golden section proportion. The square of this golden section rectangle encloses the major portion of the facade, and the reciprocal golden section rectangle encloses the two towers. The regulating lines are the diagonals that meet just above the clerestory window, crossing the corners of the major variations in the surface of the cathedral. The center front doorway is also in golden section proportion as shown by the construction diagram. The proportion of the clerestory window is one-fourth the diameter of the circle inscribed in the square.

Notre Dame Cathedral, Paris, 1163–1235

Analysis of proportions and regulating lines according to the golden section rectangle. The entire facade is in golden rectangle proportion. The lower portion of the facade is enclosed by the square of the golden rectangle and the towers are enclosed by the reciprocal golden section rectangle. Further, the lower portion of the facade can be divided into six units, each another golden rectangle.

Proportion Comparison

The clerestory window is in proportion of 1:4 to the major circle of the facade.

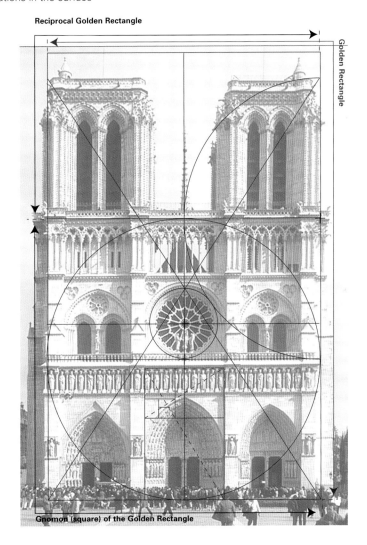

Reciprocal Golden Rectangle

Golden Rectangle

Gnomon (square) of the Golden Rectangle

Le Corbusier's Regulating Lines

"An inevitable element of Architecture. The necessity for order. The regulating line is a guarantee against willfulness. It brings satisfaction to the understanding. The regulating line is a means to an end; it is not a recipe. Its choice and the modalities of expression given to it are an integral part of architectural creation."

Le Corbusier, *Towards a New Architecture*, 1931

Le Corbusier's interest in the application of the geometry of structure and mathematics is recorded in his book *Towards a New Architecture*. Here he discusses the need for regulating lines as a means to create order and beauty in architecture and answers the criticism, "With your regulating lines you kill imagination, you make a god of a recipe." He responds, "But the past has left us proofs, iconographical documents, eteles, slabs, incised stones,

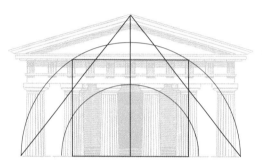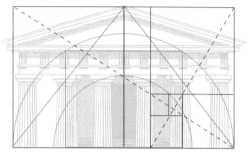

Regulating Lines
Le Corbusier cites the regulated lines of simple divisions that determine the proportion of the height to the width, and guide the placement of the columns and their proportion to the facade. The facade fits into a golden section rectangle and the architrave begins at the point where the diagonal crosses the center line.

parchments, manuscripts, printed matter....Even the earliest and most primitive architect developed the use of a regulating unit of measure such as a hand, or foot, or forearm in order to systemize and bring order to the task. At the same time the proportions of the structure corresponded to human scale."

Le Corbusier discusses the regulating line as "one of the decisive moments of inspiration, it is one of the vital operations of architecture." Later, in 1942, Le Corbusier published *The Modulor: A Harmonious Measure to the Human Scale Universally Applicable to Architecture and Mechanics. The Modulor* chronicled his proportioning system on the mathematics of the golden section and the proportion of the human body.

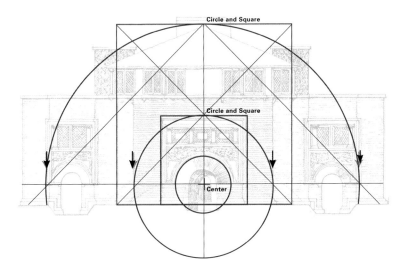

Regulating Lines
This drawing of the front facade of a house shows some of the regulating lines that were used in the design. Red lines show the regulating lines of circles, squares, and 45° angles. The circles all share the same center point and the two squares touch the top of the larger circles. The outer edges of the windows align with the largest circle and the facade aligns with the circle that surrounds the entry.

Construction of the Golden Section Rectangle

The golden section rectangle is a ratio of the Divine Proportion. The Divine Proportion is derived from the division of a line segment into two segments such that the ratio of the whole segment, AB, to the longer part, AC, is the same as the ratio of the longer part, AC, to the shorter part, CB. This gives a ratio of approximately 1.61803 to 1, which can also be expressed $\frac{1+\sqrt{5}}{2}$.

The Divine Proportion:

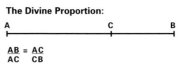

$$\frac{AB}{AC} = \frac{AC}{CB}$$

Golden Section, Square Construction Method

1. Begin with a square.

2. Draw a diagonal from the midpoint A of one of the sides to an opposite corner B. This diagonal becomes the radius of an arc that extends beyond the square to C. The smaller rectangle and the square become a golden section rectangle.

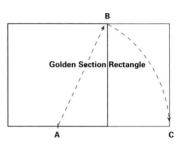

3. The golden section rectangle can be subdivided. When subdivided the rectangle produces a smaller proportional golden section rectangle which is the reciprocal, and a square area remains after subdivision. This square area can also be called a gnomon.

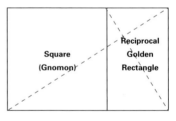

4. The process of subdivision can endlessly continue, again and again, producing smaller proportional rectangles and squares.

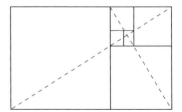

The golden section rectangle is unique in that when subdivided its reciprocal is a smaller proportional rectangle and the area remaining after subdivision is a square. Because of the special property of subdividing into a reciprocal rectangle and a square, the golden section rectangle is known as the whirling square rectangle. The proportionally decreasing squares can produce a spiral by using a radius the length of the sides of the square.

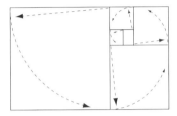

Golden Section Spiral Construction
By using the golden section subdivision diagram a golden section spiral can be constructed. Use the length of the sides of the squares of the subdivisions as a radius of a circle. Strike and connect arcs for each square in the diagram.

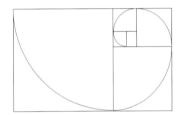

Proportional Squares
The squares from the golden section subdivision diagram are in golden section proportion to each other.

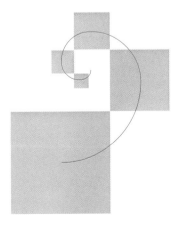

Golden Section Rectangle, Triangle Construction Method

1. Begin with a right triangle whose sides are in 1:2 proportion. Draw an arc from D, using DA as a radius, that crosses the hypotenuse.

2. Draw another arc along the hypotenuse from C using CE as a radius to intersect the base line.

3. From point B where the arc intersects the base line draw a vertical that touches the hypotenuse.

4. This method produces golden section proportions by defining the length of the sides of the rectangle, AB and BC. The subdivision of the triangle yields sides of a rectangle in golden ratio proportion, since the ratio of AB to BC is a golden section ratio of 1:1.618.

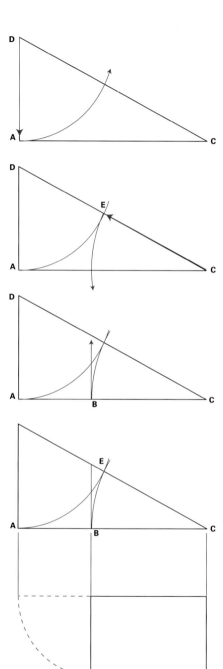

Golden Section Proportions

The divisions and proportion of the triangle method of the golden section construction produce the sides of a golden section rectangle, and in addition, the method can produce a series of circles or squares that are in golden section proportion to each other as in the examples below.

Diameter AB = BC + CD
Diameter BC = CD + DE
Diameter CD = DE + EF
etc.

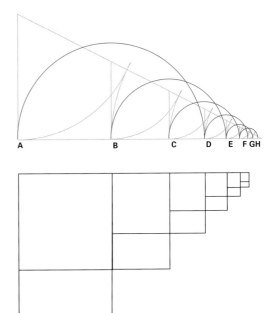

Golden Rectangle	+	Square	=	Golden Rectangle
A	+	B	=	AB
AB	+	C	=	ABC
ABC	+	D	=	ABCD
ABCD	+	E	=	ABCDE
ABCDE	+	F	=	ABCDEF
ABCDEF	+	G	=	ABCDEFG

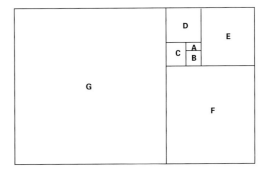

Golden Section Proportions in Circles and Squares

The triangle construction method of the golden section will also yield a series of circles or squares in golden section proportion.

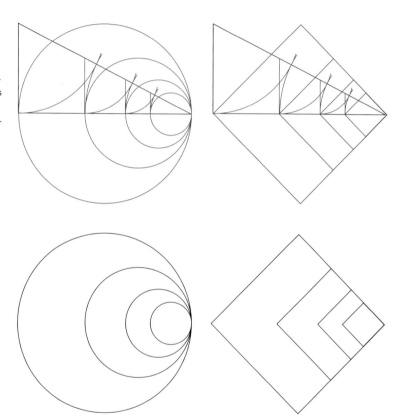

Golden Section and the Fibonacci Sequence

The special proportioning properties of the golden section have a close relationship to a sequence of numbers called the Fibonacci sequence, named for Leonardo of Pisa who introduced it to Europe about eight hundred years ago along with the decimal system. This sequence of numbers, 1, 1, 2, 3, 5, 8, 13, 21, 34... is calculated by adding the two previous numbers to produce the third. For example, 1+1=2,

1+2=3, 2+3=5, etc. The proportioning pattern of this system is very close to the proportioning system of the golden section. The early numbers in the sequence begin to approach the golden section, and any number beyond the fifteenth number in the sequence that is divided by the following number approximates 0.618, and any number divided by the previous number approximates 1.618.

Fibonacci Number Sequence

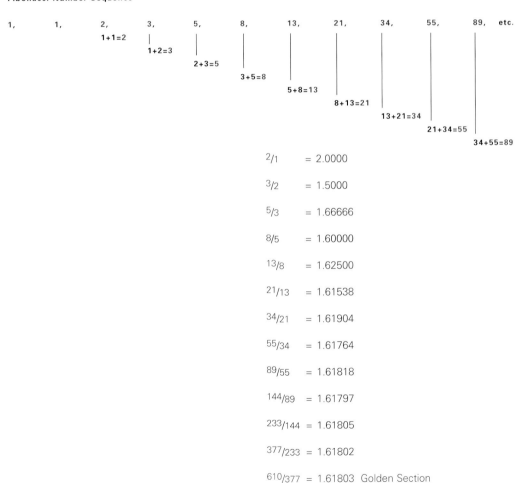

$$2/1 = 2.0000$$

$$3/2 = 1.5000$$

$$5/3 = 1.66666$$

$$8/5 = 1.60000$$

$$13/8 = 1.62500$$

$$21/13 = 1.61538$$

$$34/21 = 1.61904$$

$$55/34 = 1.61764$$

$$89/55 = 1.61818$$

$$144/89 = 1.61797$$

$$233/144 = 1.61805$$

$$377/233 = 1.61802$$

$$610/377 = 1.61803 \text{ Golden Section}$$

Golden Section Triangle and Ellipse

The golden section triangle is an isosceles triangle, having two equal sides, and is also known as the "sublime" triangle, as it has similar aesthetic properties to the golden section rectangle; it is the preferred triangle of a majority of people. It is readily constructed from a pentagon and will have an angle of 36° at the vertex and angles of 72° at the base. This construction can be further divided into another golden triangle by connecting the base angle of the larger triangle to a vertex of the pentagon at the opposite side. A continued connec-

tion of the vertices with the diagonals will result in a star pentagram. The decagon, a ten-sided polygon, will also yield a series of golden triangles by connecting the center point to any two adjacent vertices.

The golden ellipse also has been shown to have similar aesthetic qualities to the golden section rectangle and the golden section triangle. Like the rectangle, it has the same proportion of the major to minor axis of 1:1.618.

Golden Section Triangle Constructed From a Pentagon
Begin with a pentagon. Connect the angles at the base of the pentagon to the vertex of the pentagon. This will result in a golden section triangle with base angles of 72° and a vertex of 36°.

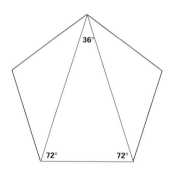

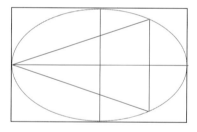

Golden Section Ellipse Inscribed Inside a Golden Section Rectangle

Secondary Golden Section Triangle Constructed From a Pentagon
The pentagon construction will also yield secondary golden section triangles. Connect a base angle to a vertex at the opposite side.

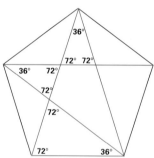

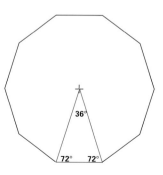

Golden Section Triangle Inscribed in a Golden Section Ellipse, Inscribed in a Golden Section Rectangle

Golden Section Triangle Constructed From a Decagon
Begin with a decagon, a ten-sided polygon. Connect any two adjacent vertices to the center to yield a golden section triangle.

Golden Section Proportions of the Star Pentagram

The five-pointed star created by the diagonals of a regular pentagon is a star pentagram, whose central part is another pentagon, etc. The progression of smaller pentagons and pentagrams is known as Pythagoras's lute, because of the relationship to the golden section.

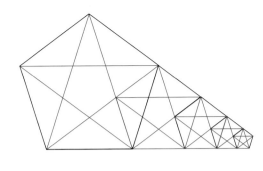

Golden Section Spiral Created with Golden Section Triangles

A golden section triangle can be subdivided into a series of smaller golden section triangles by striking a new angle of 36° from the base angle. The spiral is created by using the length of the sides of the triangles of the subdivisions as a radius of a circle.

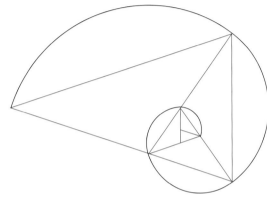

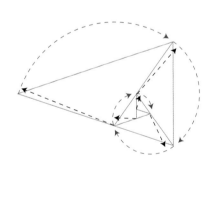

31

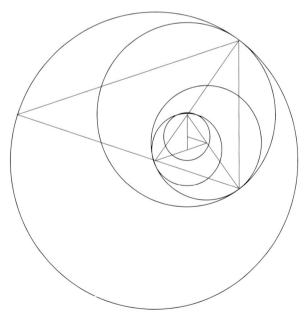

Golden Section Dynamic Rectangles

All rectangles can be divided into two categories: static rectangles with ratios of rational fractions such as 1/2, 2/3, 3/3, 3/4, etc., and dynamic rectangles with ratios of irrational fractions such as √2, √3, √5, φ (golden section), etc. Static rectangles do not produce a series of visually pleasing ratios of surfaces when subdivided. The subdivisions are anticipated and regular without much variation. However, dynamic rectangles produce an endless amount of visually

pleasing harmonic subdivisions and surface ratios when subdivided, because their ratios consist of irrational numbers.

The process of subdividing a dynamic rectangle into a series of harmonic subdivisions is very simple. Diagonals are struck from opposite corners and then a network of parallel and perpendicular lines are constructed to the sides and diagonals.

Golden Section Dynamic Rectangles

These diagrams from *The Geometry of Art and Life* illustrate a range of harmonic subdivisions of golden section rectangles. The small red line rectangles (left) show the golden section rectangle construction. The gray and red rectangles (middle) show the red golden section rectangle construction with the harmonic subdivisions in gray line. The black line rectangles (right) show only the harmonic subdivisions.

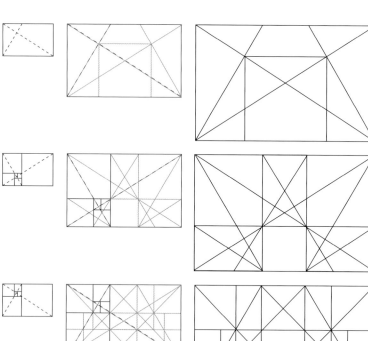

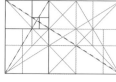
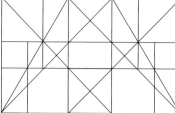

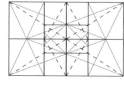
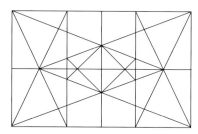

32

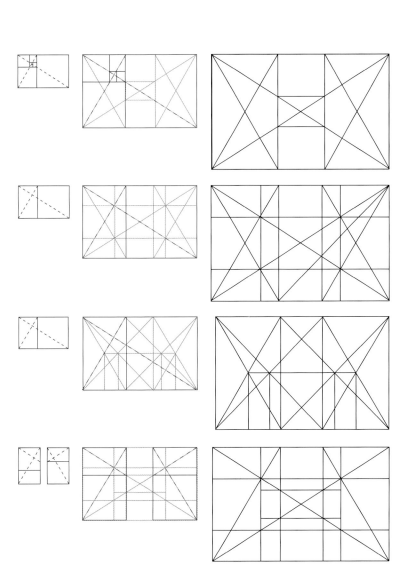

Root 2 Rectangle Construction

Root 2 rectangles possess the special property of being endlessly subdivided into proportionally smaller rectangles. This means that when a root 2 rectangle is divided in half, the result is two smaller root 2 rectangles; when divided into fourths, the result is four smaller root 2 rectangles, etc.

It should also be noted that the proportion of the root 2 rectangle approximates, rather closely, golden section proportions. Root 2 proportions are 1:1.41 and golden section proportions are 1:1.618.

Root 2 Rectangle Construction, Square Method

1. Begin with a square.

2. Draw a diagonal within the square. Use the diagonal as an arc that touches the square base line. Enclose a rectangle around the new figure. This is a root 2 rectangle.

Root 2 Subdivision

1. The root 2 rectangle can be subdivided into smaller root 2 rectangles. Subdivide the rectangle in half via a diagonal creating two smaller rectangles. Again subdivide the halves into smaller root 2 rectangles.

2. This process can be repeated endlessly to create an infinite series of root 2 rectangles.

Root 2 Rectangle Construction, Circle Method

1. Another method of constructing a root 2 rectangle is by beginning with a circle. Inscribe a square in the circle.

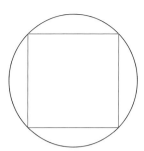

2. Extend the two opposite sides of the square so that they touch the circle. The resulting rectangle is a root 2 rectangle.

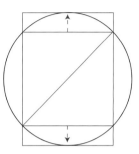

Root 2 Diminishing Spiral

A root 2 diminishing spiral can be created by striking and connecting diagonals on reciprocal root 2 rectangles.

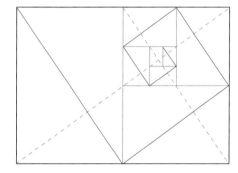

Root 2 Proportional Relationships

Subdividing a root 2 rectangle continuously produces smaller proportional root 2 rectangles.

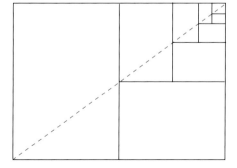

DIN System of Paper Proportioning

Root 2 rectangles possess the special property of being endlessly subdivided by proportionally smaller rectangles. It is for this reason that the root 2 rectangle is the basis for the European DIN (Deutsche Industrie Normen), a system of paper sizes. Therefore, it is also the same proportion of many of the European posters examined in this book. Folding the sheet once produces the half sheet or folio. The sheet folded four times results in 4 leaves or 8 printed pages, etc. This system is not only efficient but also optimizes the use of paper through a system that has no waste. European cities with a rich poster tradition have standardized display areas of street posters in this proportion. Not only does the root 2 rectangle have the functional property of eliminating waste but also closely follows the aesthetic properties of the golden section.

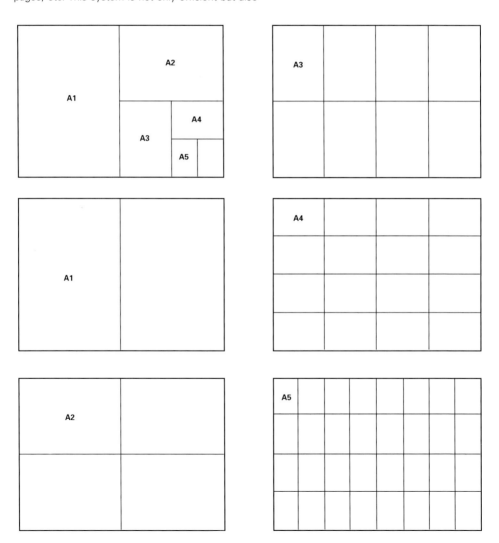

Root 2 Dynamic Rectangles

Similar to the golden section rectangle, root 2 rectangles are known as dynamic rectangles because, like golden section rectangles, they produce a variety of harmonic subdivisions and combinations that are always related to the proportions of the original rectangle.

The process of harmonic subdivision consists of drawing diagonals and then drawing a network of parallel and perpendicular lines to the sides and diagonals. The root 2 rectangle will always subdivide into an equal number of reciprocals.

Harmonic Subdivisions of Root 2 Rectangles
(left) Division of a root 2 rectangle into sixteen smaller root 2 rectangles.
(right) Division of a root 2 rectangle into four columns and adjacent angles.

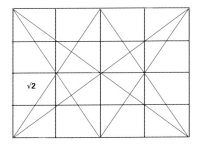

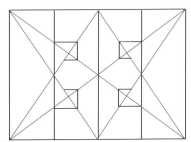

(left) Division of a root 2 rectangle into nine smaller root 2 rectangles.
(right) Division of a root 2 rectangle into three smaller root 2 rectangles and three squares.

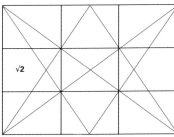

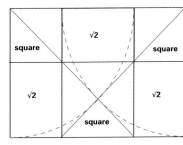

(left) Division of a root 2 rectangle into five root 2 rectangles and two squares.
(right) Division of two root 2 rectangles.

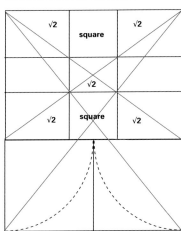

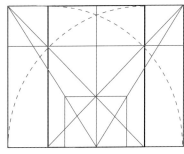

Root 3 Rectangle

Just as the root 2 rectangle can be divided into other similar rectangles, so too can the root 3, root 4, and root 5 rectangles. These rectangles can be subdivided both horizontally and vertically. The root 3 rectangle can be subdivided into three root 3 vertical rectangles; these vertical rectangles can be subdivided into three root 3 horizontal rectangles, etc.

The root 3 rectangle has the property of enabling the construction of a regular hexagonal prism. This hexagon can be found in the shape of snow crystals, honeycombs, and in many other facets of the natural world.

Root 3 Construction
1. Begin with a root 2 rectangle.

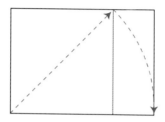

2. Draw a diagonal within the root 2 rectangle. Use the diagonal as an arc that touches the square base line. Enclose a rectangle around the new figure. This is a root 3 rectangle.

Root 3 Subdivision
The root 3 rectangle can be subdivided into smaller root 3 rectangles. Subdivide the rectangle in thirds to create three smaller rectangles. Again subdivide the thirds into smaller root 3 rectangles. This process can be repeated endlessly to create an infinite series of root 3 rectangles.

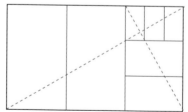

Hexagon Construction

A hexagon can be constructed from a root 3 rectangle. This is done by rotating the rectangle from a center axis so that the corners meet.

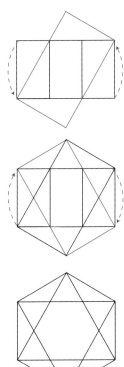

Root 4 Construction
1. Begin with a root 3 rectangle.

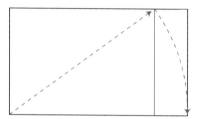

2. Draw a diagonal within the root 3 rect-
angle. Use the diagonal as an arc that
touches the square base line. Enclose a
rectangle around the new figure. This is a
root 4 rectangle.

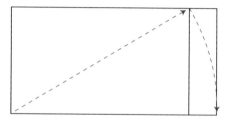

Root 4 Subdivision
The root 4 rectangle can be subdivided
into smaller root 4 rectangles. Subdivide
the rectangle into fourths, creating four
smaller rectangles. Again subdivide the
fourths into smaller root 4 rectangles.
This process can be repeated endlessly
to create an infinite series of root 4 rect-
angles.

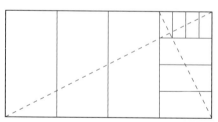

Root 5 Rectangle

Root 5 Construction
1. Begin with a root 4 rectangle.

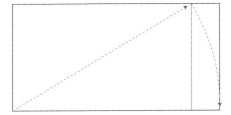

2. Draw a diagonal within the root 4 rectangle. Use the diagonal as an arc that touches the square base line. Enclose a rectangle around the new figure. This is a root 5 rectangle.

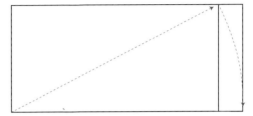

Root 5 Subdivision
The root 5 rectangle can be subdivided into smaller root 5 rectangles. Subdivide the rectangle in fifths to create five smaller rectangles. Again subdivide the fifths into smaller root 5 rectangles. This process can be repeated endlessly to create an infinite series of root 5 rectangles.

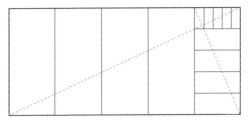

Root 5, Square Construction Method
Another method for construction of a root 5 rectangle begins with a square. An arc is struck from the center of the bottom edge of a square. Then the square is extended to include the arcs on both sides.

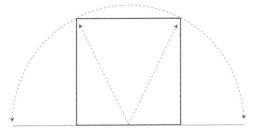

The small rectangles on either side of the square are golden rectangles, and one of the small rectangles and the center square form another golden rectangle. Both golden rectangles and the square are a root 5 rectangle.

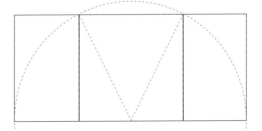

Comparison of Root Rectangles

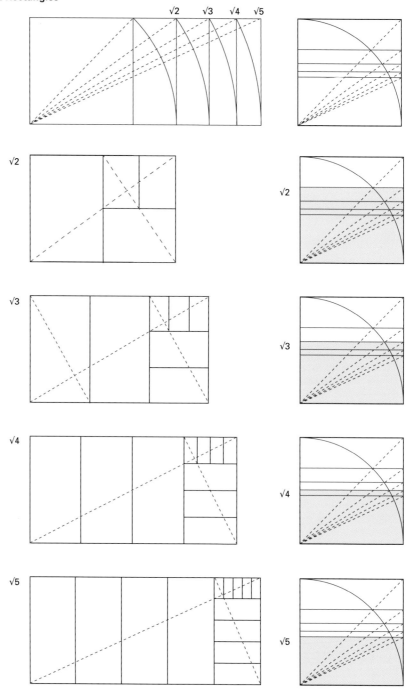

Visual Analysis of Design

There is no better way to begin to view the analysis of graphic design, illustration, architecture, and industrial design than with an introduction by Le Corbusier.

In *The Modulor*, Le Corbusier writes of his revelation as a young man in Paris: "One day, under the oil lamp in his little room in Paris, some picture postcards were spread out on his table. His eye lingered on a picture of Michelangelo's Capitol in Rome. He turned over another card, face downward, and intuitively projected one of its angles (a right angle) on to the façade of the Capitol. Suddenly he was struck afresh by a familiar truth: the right angle governs the composition; the *lieux* (*lieu de l'angle droit*: place of the right angle) command(s) the entire composition. This was to him a revelation, a certitude. The same test worked with a painting by Cézanne. But he mistrusted his own verdict, saying to himself that the composition of works of art is governed by rules; these rules may be conscious methods, pointed and subtle, or they may be commonplace rules, tritely applied. They may also be *implied* by the creative instinct of the artist, a manifestation of an intuitive harmony, as was almost certainly the case with Cézanne: Michelangelo being of a different nature, with a tendency to follow preconceived and deliberate, conscious designs.

A book brought him certainty: some pages in Auguste Choisy's book on the *History of Architecture* devoted to the tracé regulateur (regulating lines). So there were such things as regulating lines to govern composition?

In 1918 he began to paint in earnest. The first two pictures were composed haphazardly. The third, in 1919, was an attempt to cover the canvas in an ordered manner. The result was almost good. Then came the fourth painting, reproducing the third in an improved form, with a categorical design to hold it together, enclose it, give it a structure. Then came a series of pictures painted in 1920 (exhibited at the Galerie Druet, 1921); all these are firmly founded on geometry. Two mathematical expedients were used in these paintings: the place of the right angle and the golden mean."

Le Corbusier's revelation is one that is of value for all artists, designers, and architects. The understanding of the underlying organizational principles of geometry brings to a creative work a sense of compositional cohesiveness, whereby each element of the work has a visual sense of belonging. By revealing some of the geometry, systems, and proportions it is possible to understand better the intent and reasoning of a number of designers and architects. It gives insight into the process of realization and a rational explanation for many decisions, whether the use of organizational geometry is intuitive or deliberate, rigidly applied or casually considered.

The Process of Geometric Analysis

Geometric analysis identifies the proportioning systems and regulating lines that contribute to the cohesive composition of a work of art, a building, a product, or a work of graphic design. While this analysis does not examine the concept, the culture, or the medium, it does reveal compositional principles and often confirms the positive intuitive response of the viewer through quantifiable means of proportion and alignment.

The value of geometric analysis is in the discovery of underlying ideas and principles of design that were used by the artist, architect, or designer. These are the key ideas of composition that guide design, and the arrangement of elements within a composition provide insight into the decisions that were made. The process of geometric analysis is one of investigation, experimentation, and discovery. There are no strict rules, only a series of compositional methods that have been developed and used for centuries.

Le Corbusier's idea of regulating lines is important in geometric analysis because they identify interrelationships that are essential in cohesive compositions. Some works may not conform to classic proportioning systems but will have a series of interrelationships that can be analyzed with regulating lines. These lines can reveal alignments between elements, organizational principles, and visual directions.

The works chosen for this book were selected because they can be analyzed through geometry and insight can be gained through the process. Architects are particularly knowledgeable about geometry and keenly aware of the benefits of proportioning systems in their work. Hence, many of the chairs, products, and all of the buildings in this book were designed by architects. European graphic designers are also highly aware of proportioning systems and their use in design. The standardized use of the root 2 rectangle in communication materials and for street posters makes for an acute awareness of proportion and its use in design.

Geometric Analysis, Proportion

The proportion of a work is central to the composition in that it establishes a series of visual relationships, not only between the length and width but also the between the elements and the whole. Few viewers will recognize the presence of a specific proportion but they will sense the harmony and interrelationships that are created.

Simply, proportion is the relationship of the length to the width of a rectangle and some of the most common systems include the golden section at 1:1.618, root 2 at 1:1.41, 1:2, 2:3, 3:4, etc. Proportion can be determined by mathematics or by comparison of a construction diagram with the work. When computing proportion mathematically, measure both sides of the rectangle and if necessary convert the measurements to decimals. Divide side A by side B. For example, side A = 20" and side B = 10" then A/B = 20/10 or a proportion of 2:1.

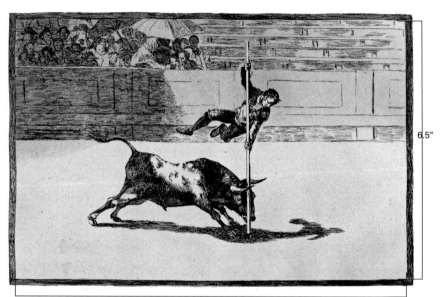

6.5"

10.6" Print Size

Tauromaquia 20, Goya, 1815-16

This aquatint etching by Goya captures the dynamic acrobatics of a toreador during a bullfight. Goya was known as one of the last of the classical painters and he studied the old masters. It's highly likely that he was aware of and used a proportioning system and organized the drawing elements according to classic tradition. Clearly, the vertical pole in the drawing is carefully placed in the format as are the central figures, the toreador and bull and their poses.

The interior portion of the print, inside the drawn frame, measures 10.06" x 6.5". Using the mathematical system to calculate proportion, which the equation is 10.06/6.5 = 1.55. The proportion is 1:1.55, which is close to the golden section proportion of 1:1.618.

Geometric Analysis, Proportion

Golden Section Rectangle
Since the proportion is close to golden section proportions, placement of a golden section construction diagram on top of the print confirms that this is a fairly close match. With this match observations can be made regarding the composition of the drawing:

1. The diagonal follows the angle of the toreador past the head and from the shoulder to leg through the rear legs of bull.

2. The vertical pole is to the left of the reciprocal golden section rectangle.

3. The head of the toreador is inside the smallest golden section reciprocal rectangle.

4. The top of the square of a reciprocal golden section rectangle aligns within the structure of the arena.

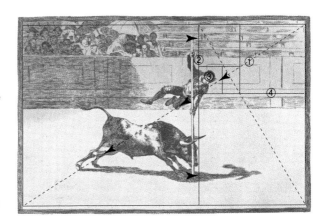

Reflected Golden Section Rectangle
Reflecting the golden section rectangle yields still more information about the drawing. Additional observations can then be made:

1. The reflected diagonal from upper left to lower right touches the foot of the toreador, the horns of the bull, and the shadow, as it follows the arch of the bull's neck.

2. The tail of the bull touches the diagonal of the reciprocal golden section rectangle.

3. The center of the drawing is in the air between the neck of the bull and the legs of the toreador. The horizon of the arena structure is just above the center point.

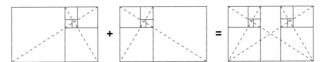

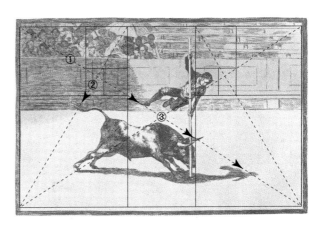

47

Geometric Analysis, Compositional Grids

While Goya's *Tauromaquia 20* appears to have a compositional arrangement that can be analyzed by the golden section rectangle, this discovery does not eliminate the possible presence of other organizational systems. In the golden section analysis the strongest alignments are with the corner to corner diagonals and those same diagonals will be present in a grid structure as well. The alignment with the toreador's pole and the golden section construction diagram is close but not exact. The presence in the work of such a dominant vertical element as the pole and the dominant horizontal arena structure are clues that there may be an alternate compositional structure. Below are diagrams that describe the process of searching for a grid.

Grid Structure Beginning
When seeking a grid structure in a work of art or design, look for dominant vertical and horizontal lines as a starting point. There is one very dominant vertical in the composition, the toreador's pole. The dominant horizontal lines are in the arena structure. These three lines become the starting point for a possible grid structure.

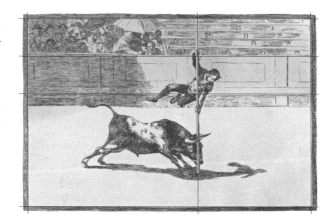

Grid Structure
By working from the potential known grid lines, shown above, the remainder of the grid structure can be developed. In this case a 5 column x 5 row grid structure fits well. The 5 x 5 structure creates asymmetry as the toreador and pole align along the second column from the right. The bull is enclosed in four visual fields and portions of the arena structure and crowd occupy the top two rows.

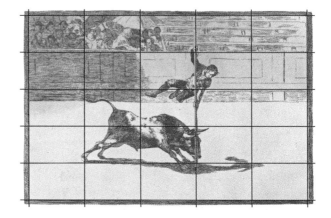

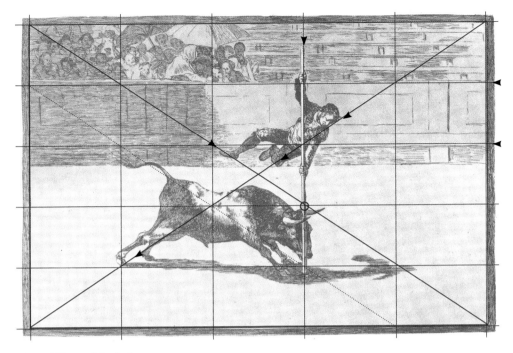

Grid and Diagonal Analysis
The diagonals describe and reflect the angles in the position of the toreador and the bull. The vertical lines position the dominant pole. The horizontal lines describe the arena structure and crowd. Each of the rectangles in the grid is a visual field, and because the diagonal lines pierce the corners of each visual field, the visual fields are in the same proportion as the drawing.

Golden Section Point
The interior point where the square of the reciprocal golden section rectangle meets the next reciprocal rectangle is called the golden section point. This point was favored by Renaissance painters as the optimum location for a compositional element of interest. The point is asymmetric as it is to the right of center and slightly below.

The idea of the golden section point can be applied to any rectangle. To find the golden section point in any rectangle divide the rectangle into a grid of five columns and five rows. The golden section point is two columns from the right and two rows from the bottom. No matter what the proportion of the rectangle the diagonal from upper left to lower right will touch the point. The golden section point in the Goya print, shown above with a red circle, is just above the horns of the bull.

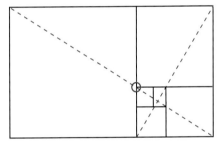

The Golden Section Point

The Golden Section Point of a Rectangle

Geometric Analysis, Rabatment

The method of rabatment is close to golden section analysis and has been called the "lazy man's golden section." Rabatment is a compositional method that consists of placing a square, with a side equal to the edge of the rectangle, over the left and right sides of the composition. The resulting verticals and diagonals create a compositional structure. All horizontal rectangles have both a left and right rabatment and all vertical rectangles have both a top and bottom rabatment. The rabatment structure suggests asymmetry, assists the artist in positioning elements in the composition in a visually interesting way, and creates a proportional relationship between the elements, placement, and the rectangle. The area of overlap by the two squares in a left and right rabatment can be used for a secondary rabatment and the same method of construction applies as the top and bottom squares overlap and create horizontals.

50

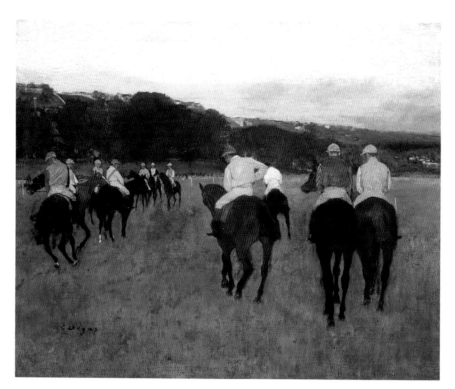

Racehorses at Longchamp, **Edgar Degas (Hilaire-Germain-Edgar De Gas), c. 1873–75**

Degas studied at the École des Beaux-Arts in Paris and traveled to Italy to study and copy the classic master painters such as Raphael and Botticelli. While he is better known for his many paintings of ballet dancers, race horses were another favorite theme and the painting, *Racehorses at Longchamp,* is one of these.

Rabatment

The rabatment method organizes the painting. The left, red, rabatment edge splits the pair of foreground riders and the right, black, rabatment edge divides the group of seven riders. Diagonals from the rabatment squares enclose and follow the angle of the group of horses and riders at left and right. The center figure, in pink silks, is just to the right of the vertical center, with the jockey's head at the meeting of the diagonals.

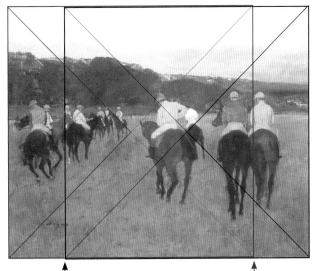

Right Rabatment Edge Left Rabatment Edge

Horizontal Format

Left Rabatment

Right Rabatment

Overlapping Left and Right Rabatments

Secondary Rabatment

The overlapping area of the two rabatment squares, shown above, is a vertical rectangle. A secondary rabatment is created when two squares are placed in the overlapping area to create a secondary rabatment with two horizontal lines. This area encloses the center of the composition and defines the edge of the hills and sky above and the grassy area below.

Secondary Rabatments Top and Bottom

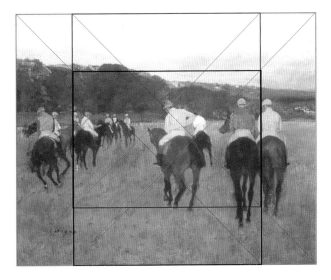

Geometric Analysis, The Diagonal and Center

One of the simplest tools of visual analysis is to locate the diagonals in a composition. The diagonal line is the most dynamic line and it implies direction and movement. The diagonals, from corner to corner, of any square or rectangle cross at the center of the composition and the lines can become organizational tools. Classic paintings often use the diagonal and elements that are aligned along the diagonal feel comfortable and purposeful as they pull the viewer's eye along the line.

The center is a key position in any composition because both diagonals run through it and the eye will naturally seek it. In Albert Baertsoen's *Ghent, Evening*, below, the arrangement of the objects in the painting is asymmetric. Interestingly, the oarlock on the barge is at the center and creates a small pause for the viewer.

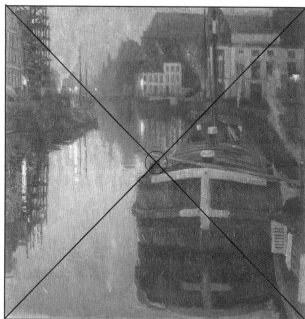

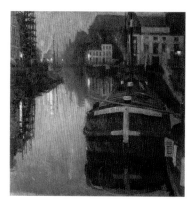

Ghent, Evening, **Albert Baertsoen, 1903**
Although rarely noticed by the casual viewer, the role of the diagonal is strong in *Ghent, Evening*. The canvas is almost a square and attention is focused on the canal, boats, and city rather than the proportion of the format. The largest object is the foreground barge and a diagonal runs closely along its left side and through the upraised oarlock at the center of the painting. The opposite diagonal follows the edge of the buildings and passes through the moon.

Geometric Analysis, The Rule of Thirds

In art and design odd numbers are magic numbers because when used as an organizational device they inspire asymmetry, which often makes a composition more visually interesting. The rule of thirds suggests that when a rectangle or square is divided into thirds vertically and horizontally, the four intersecting points within the composition are the points of optimal focus. The artist or designer uses placement and proximity to determine which of these points is hierarchically the most important.

An awareness of the law of thirds enables the artist or designer to focus attention where it will most naturally occur and to control the compositional space. Elements do not need to land directly on the intersecting point as close proximity will draw attention to them.

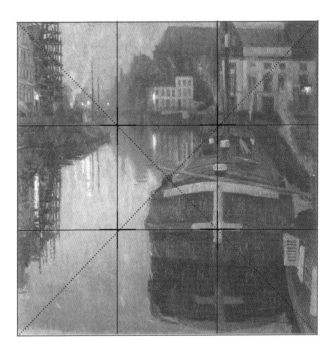

Rule of Thirds Grid
Placing a 3 x 3 grid over *Ghent, Evening* reveals additional insights about the structure of the composition. The buildings and their reflection occupy the left column. The barge stern is split in half by the right column grid line, and the white painted lines on the barge align with the lower right intersecting grid point. The reflection of light in the water is just below the lower left point, and the upper two points land in the water and at the bow of the barge. The diagonals pass through the intersecting points.

Vienna Chair (Model No. 14), Michael Thonet, 1859

From the time it was introduced in 1859, Michael Thonet's Model No. 14, commonly called the Vienna Chair, was a huge international success. The reasons for this success stem from the confluence of the refinement of the bentwood process, efficiency of assembly line production, the light weight of the chair, its durability, and the cost-effective price of only three gulden. Thonet had first developed the bentwood technical process in the 1830s and was granted a patent in 1842. After exhibiting his furniture in the Crystal Palace in London in 1851, Thonet furniture was on its way to becoming an international sensation. His techniques with the bentwood process laid the foundations for twentieth century furniture design innovations by Alvar Aalto and Charles Eames with bent and molded plywood, and Mies van der Rohe and Marcel Breuer with bent-metal tubing.

The driving force behind Thonet's furniture was the desire for cost-effective quality in design and manu-

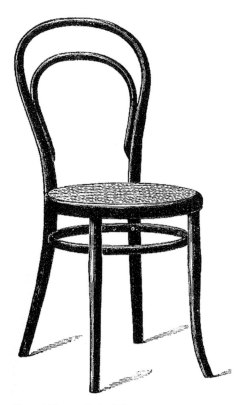

Thonet Vienna Chair, #14
Illustration from the Thonet Catalog

Variations on the Vienna Chair
Three variations of the popular Vienna chair: #20, #29, #31.

54

facture. In keeping with these ideas, the furniture was purely functional and without embellishment. The Vienna Chair could be shipped knocked down in only six parts: a circular seat with a compression ring to stretch the caning, two front legs, a single looped rod that formed the back legs and upper back frame, a smaller loop support that fit inside the back frame, and a circular ring to support the legs. While the Vienna Chair has remained the most popular, over 100 variations were produced.

The simplicity of the Vienna Chair is appealing, and each member of the frame is required for the structure to function. The proportions of the chair are pleasing and the curves are lyrical as the eye easily follows the tapered flare of the legs up and around the loop of the back. Although the wood is a hard material, the curves of the frame and circle of the seat invite the user to sit and rest.

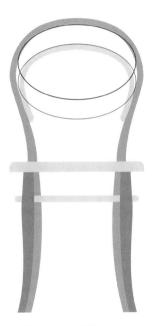

Center Point

Golden Section Ellipses
The two curves of the back frame are golden section ellipses. It is unlikely that the shape of the back supports was planned. Rather, the shape is the natural result of the bentwood process and is the curve that suited the wood. The bentwood process involved lathing a rectangular piece of wood into a dowel shape, soaking the wood in water, steaming the wet wood, and placing it in a mold to dry and harden.

Golden Section Rectangle
The side view of the chair fits well in a golden section rectangle. The reciprocal golden section rectangle is at the ring that supports and stabilizes the four legs. The interior back support ends near the large square of the golden section rectangle.

Folies-Bergère Poster, Jules Chéret, 1877

Folies-Bergère by Jules Chéret is an engaging and dynamic work that captures the movement of a group of dancers. At first glance the composition appears spontaneous and without geometric organization but closer examination reveals a very carefully developed visual structure. The positions of the dancers' limbs closely correspond to a pentagon embraced by a circle.

The interior subdivisions of the pentagon create star pentagrams which in turn create a smaller proportional pentagon. The ratio of the sides of the triangles within a star pentagram is 1:1.618, the golden section ratio. The exact center of the poster is a pivot point on the female dancer's hip, and the legs of the male dancers create an inverted triangle, the top point of the pentagram star, that embraces the female dancer. Each limb and shoulder is carefully positioned according to the geometry of the structure.

56

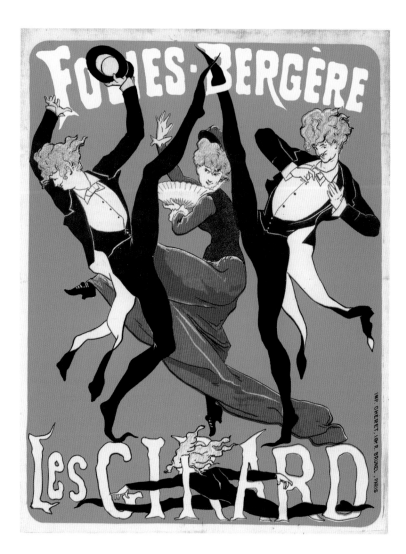

The Star Pentagram

The subdivisions of the pentagon create an interior star whose center is a pentagram. The golden section is present in that the triangles have two equal sides, B or C, that relate to the third side, A, as 1: 1.618, the golden section ratio.

Analysis

The three figures are embraced first by a circle, then by a pentagon, next by a star pentagram and finally by a pentagon, with the center as a pivot point from the female dancer's hip. Even the small elfin figure at the bottom plays into this structure as the head meets the circle and pentagon.

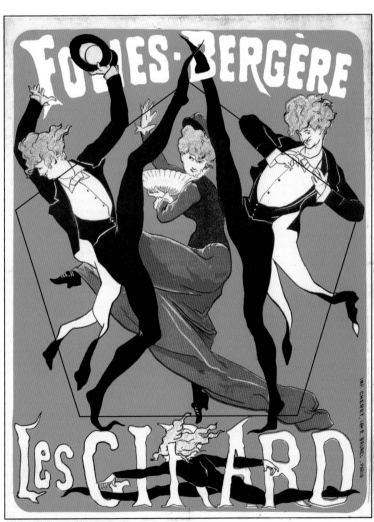

Golden Section Triangle

The triangle created by the dancers legs is a golden section triangle.

Bathing at Asnières, Georges-Pierre Seurat, 1883

Georges-Pierre Seurat was classically educated as an artist at one of Europe's premier fine art academies, L'École des Beaux-Arts in Paris. The academy was the powerful center of fine art education and held a tight monopoly on exhibitions and work selected for exhibition. Admission to the academy provided an entry into the fine art world and likely future prosperity for its students. The academy's demanding curriculum emphasized study of classi-cal Greek and Roman art and architecture which included mathematical principles. It is here that Seurat learned about visual organization and propor-tioning systems including the golden section.

Bathing at Asnières was Seurat's first monumental work as a painter, and was completed when he was just 24 years old. The canvas is a massive 79" x 118" (201 cm x 300 cm). The painting was rejected for

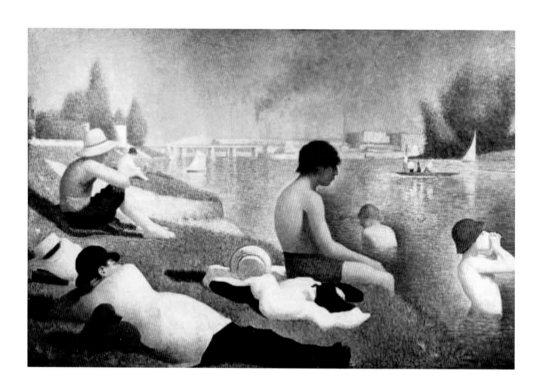

exhibition by the established Paris Salon and prompted Seurat to join other artists in creating the Société des Artistes Indépendants. Later, the painting was exhibited with four hundred others in the Société but due to its massive size was hung in the exhibition beer hall where it met with scant attention, tepid reviews, and criticism for the commonplace subject matter of working men enjoying a swim on a hot summer day.

Intrigued with color and its application to the canvas, Seurat experimented with a painting technique of crosshatching that he had developed, which he termed *balayé*. This technique involves a flat brush applying paint with larger strokes in the foreground and smaller strokes in the background, thereby increasing the sense of depth and perspective. Later, Seurat would develop another technique, pointilism, for his second and final masterwork, *A Sunday on La Grande Jatte*.

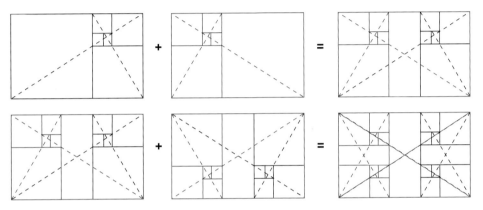

Construction of the Golden Section Dynamic Rectangle
The golden section dynamic rectangle consists of four overlapping golden section rectangles. Beginning with a single rectangle it is copied and reflected vertically, and then copied and reflected horizontally.

Golden Section Dynamic Rectangle
The golden section dynamic rectangle placed over the painting shows that the focal point, the seated figure, is placed at the square of the golden section rectangle. The horizon is at the square of the reciprocal golden section rectangle and the diagonals touch the angle of the seated figure's neck and arms, the back of the figure in the water, and both the reclining figure and seated figures in the background.

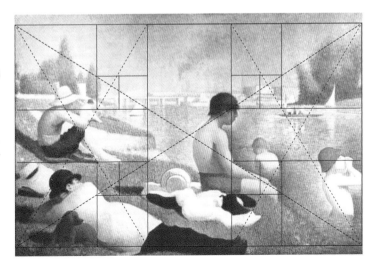

Rabatment

The *Bathing at Asnières* painting is a horizontal rectangle and the left rabatment square is shown in blue. The main seated figure is aligned at the right side of the square and the two figures in the water are placed outside the rabatment. The right rabatment square, shown in red, splits the reclining figure with the seated figures resting outside.

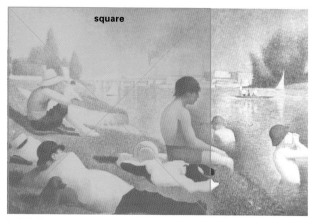

Left Rabatment

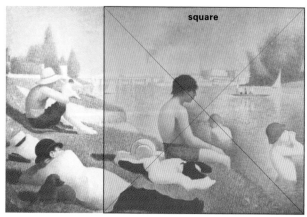

Right Rabatment

Rabatment and Grid

Placing both the left and right rabatment over the composition reveals that the composition is divided vertically into thirds. The addition of horizontal lines, again dividing the composition in thirds, shows a 3 x 3 grid structure. Each grid rectangle is in the same proportion as the canvas.

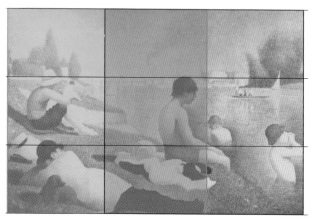

Left and Right Rabatment Resulting in a 3 x 3 Grid

3 x 3 Diagonal Grid

Diagonals placed on the 3 x 3 grid reveal placement and direction in the composition. A number of elements in the painting correspond to the grid diagonals: 1. the reclining figure in the foreground, 2. the legs of the seated background figure, 3. the slumped neck as well as the arms and legs of the largest seated figure, 4. the arms of the figure in the water, 5. the angle of the grassy land and background trees follow the diagonal, and 6. the horizon follows the horizontal of the top third of the composition.

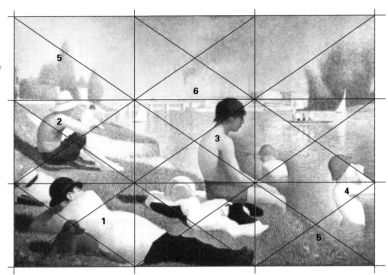

Circles

Circles formed by the heads and hats guide the viewer's eye direction in the composition. Each of the large circles are about the same size. The head of the smaller bather in the water is enclosed by a small circle that is half the diameter of the large circle. The head of the seated figure in the far background is about half the diameter of the small circle, making all of the heads in proportion to each other. The viewer's eye rests on the circles and groups them in a series of patterns.

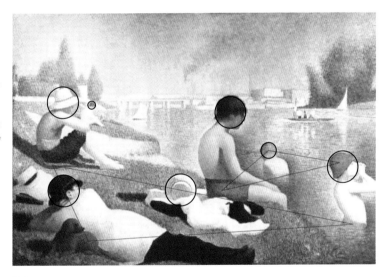

Color

The use of color also controls the viewer's eye. The rusty red is repeated in the dog, bather's trunks, hats, and cushion. The viewer makes visual connections among patches of red in a triangular manner connecting the patches of red.

Job Poster, Jules Chéret, 1889

Chéret was a master lithographer and is credited with elevating the chromolithography printing process to an art form. His knowledge of chromolithography printing grew from an apprenticeship begun at age 13. The only formal education he received in art and design was a course at the École Nationale de Dessin. It is perhaps in this course that he was introduced to geometry and the principles of composition. Although his formal education was limited, throughout his career he made the major art museums of Europe his personal schools and carefully studied the works of the masters.

Many of Chéret's posters were instant successes because of the beautiful play in color and the delightful illustrated figures. He understood the chromolithographic printing process and used it to his advantage. He also understood the principles of composition and used them to unify this and many other works.

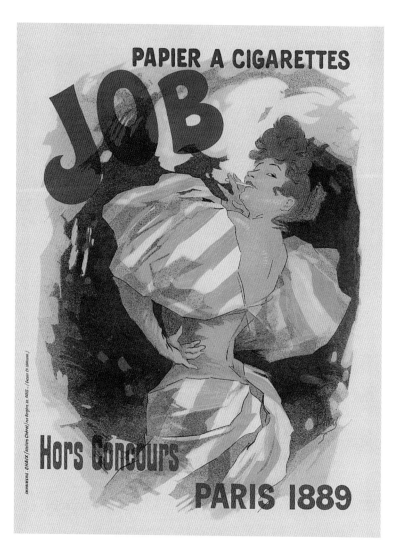

The Star Pentagram and Format Proportion

Expanding the star pentagram inscribed in a circle reveals that the poster format proportions are based on this system known as the "pentagon page." The base of the poster conforms to the bottom side of the pentagram and is extended so that the top corners meet the circle.

Analysis

A circle with its center at the center of the page governs the placement of the figure and the type, "JOB." The upper right to lower left diagonal visually organizes the placement of the head, eye, and hand. The upper left to lower right diagonal flows through the shoulder and past the hip.

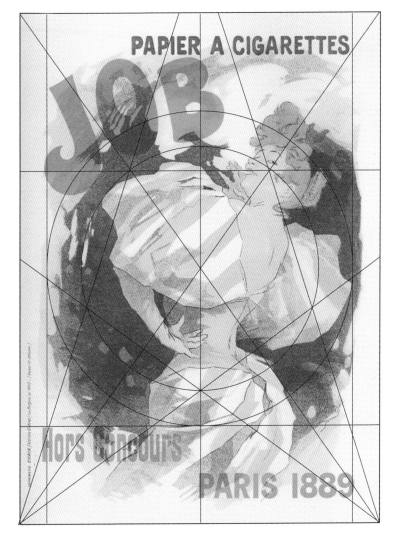

Ball at the Moulin Rouge, Henri de Toulouse-Lautrec, 1889-90

Henri de Toulouse-Lautrec was hard to miss in the bohemian art scene in Montmartre, Paris. Congenital birth defects and broken legs as a teen had resulted in his having abnormally short legs on a normal adult torso. His physical limitations caused him to focus on drawing and painting, and through his wealthy family he received encouragement and an income throughout his life. He studied art informally as a child and later under classically trained portrait painter Léon Bonnat, who would later become the director of the École des Beaux-Arts in Paris.

The Moulin Rouge cabaret opened in 1888 to entice a more bourgeois clientele through its doors than the other seamy Montmartre cabarets. Toulouse-Lautrec captures this scene through the painting *The Ball at the Moulin Rouge*. He portrays the contrast of the sedate well-dressed woman in the foreground with a lively free-spirited dancer who is kicking up her legs and showing her petticoats. Toulouse-Lautrec effectively uses color to focus attention on the two central figures, the foreground woman in pink and the dancer with red hair and bright red stockings.

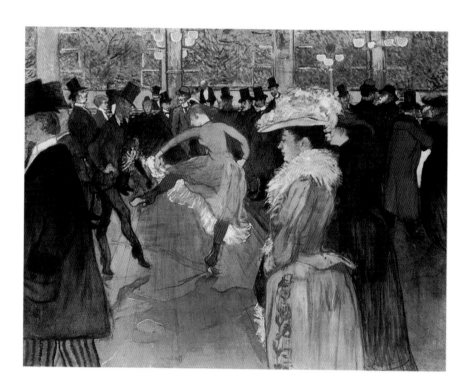

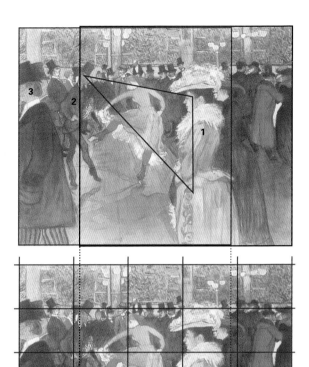

Rabatment

The rabatment method of composition reveals that the foreground female figure, 1, in pink is aligned near the side of the left, red, rabatment square. The midground male figure, 2, is on the left edge of the right, black, rabatment square. The cropped foreground figure, 3, is inside the left section. The focus is in the rabatment overlap in the middle, and on the contrast between the dynamic diagonals of the center dancer and the sedate vertical woman in pink. A compositional triangle is created as the viewer groups these three figures. Toulouse-Lautrec keeps the viewer focused on the triangle by cropping and hiding faces so that the only faces that are clearly seen are those in the triangle.

Grid

A 5 x 5 grid pattern relates to the organization of the compositional elements and the right and left columns are close to the rabatment diagram above. The strongest horizontal is at the top row and this line runs through the top hats and the structure. The male and female foreground figures occupy the same amount of space and the bright pinks and yellows make the female figure appear to advance while the muted brown and gray tones make the male figure recede.

Diagonals and Center of Canvas

The left, solid black diagonal relates to the placement of the head of the midground male figure, 1, and the diagonal of the dress of the dancing mid-ground female figure, 2. The right, solid red diagonal runs through the head of the foreground female figure and touches the toe of the mid-ground male figure, 1. The dancing female figure is asymmetrically placed to the left of the center and the diagonal follows her upraised leg as well as the angle of the male dancer's arm.

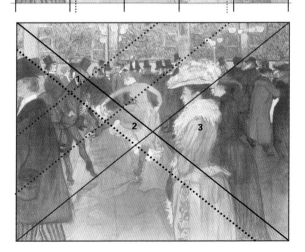

La Goulue Arriving at the Moulin Rouge with Two Women, Henri de Toulouse-Lautrec, 1892

Because of his severe disabilities and short stature, Toulouse-Lautrec was subjected to ridicule throughout his life and found acceptance from those on the fringe of society including cabaret dancers and prostitutes. They were his friends, his lovers, and a favorite subject for his drawings and paintings.

La Goulue (The Glutton), the center figure in the painting, was the celebrated Moulin Rouge dancer Louise Weber, who would kick off the top hats of the dance hall patrons and as they turned to pick up their hat, quickly chug their drinks while dancing. Lautrec portrays her as saucy, vivacious, and worldwise. Her lightly colored dress is highlighted by the dark dresses of the women on either side. A master of controlling direction in his paintings, Lautrec uses the diagonal of the low-cut dress and repeats it in the angles of the arms. La Goulue's dainty right hand is in contrast to the paw-like hand of the figure on the left holding her arm.

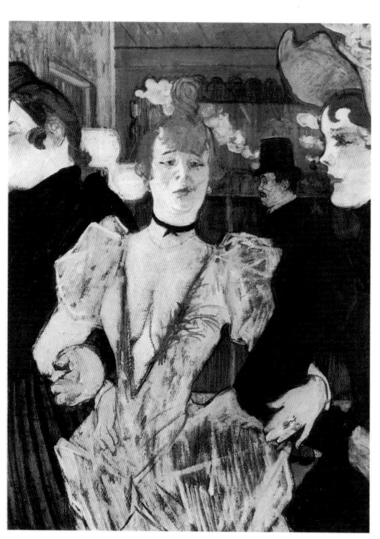

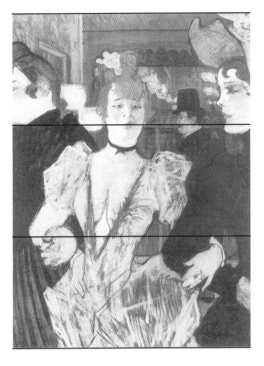

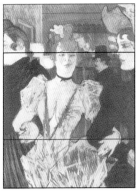

Organization by Thirds and Rabatment

Both the thirds and rabatment methods of organization can be used to analyze the composition. The rabatment of the painting, above, highlights the figures from waist to eyes. Organization by thirds, left, shows the heads of the figures are at the top third line of the composition, the torso of the central figure in the middle third, and waist and hands in the lower third. The horizontal line of the window opening is just at the top third line, which runs through the lips of the center figure.

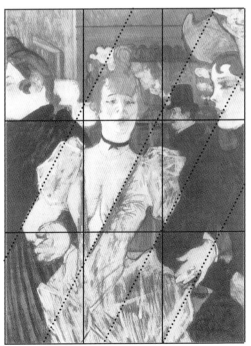

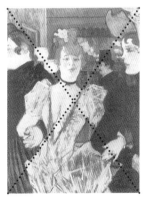

Diagonals and Grid

The corner to corner diagonal, above, organizes the position of the head and shoulder of the cropped left figure and runs through the hand at lower right. The most potent diagonal is along the décolletage and open dress of the central figure, left. This same angle is repeated in the position of the arms and right-side hand. Vertically, the painting is organized roughly in thirds with the middle figure placed asymmetrically, slightly to the left.

Argyle Chair, Charles Rennie Mackintosh, 1897

Charles Rennie Mackintosh was an architect, painter, interior designer, and furniture designer. Loosely associated with Art Nouveau and the Arts and Crafts movement at the turn of the century, his furniture design is even today startling for its unique visual language of exaggerated proportions, graphic quality of its geometric forms, and restrained ornamentation. He believed that the architecture, interiors, and furnishings needed to fully harmonize.

In 1896 Mackintosh came under the patronage of the eccentric and highly successful businesswoman Kate Cranston and designed murals and light fixtures for her Argyle Street Tea Room. It was for the tea room expansion that Mackintosh designed the tall ellipse-backed Argyle chair. This chair is his first high-backed chair and is acknowledged as the first truly original "Mackintosh chair." It signaled the beginning of furniture design with his unique style.

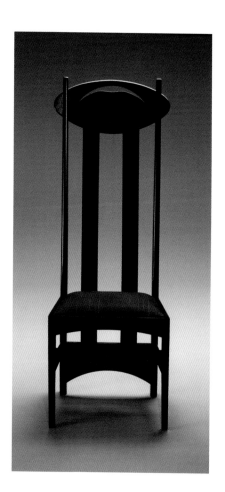

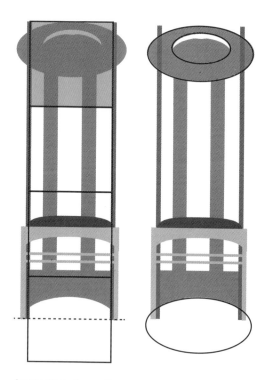

Argyle Chair Proportions

The height of the Argyle chair is immediately arresting. The tall chair seems even taller due to the two cylindrical back legs that extend up and over the oval and flat back planes that meet the oval. The proportion of the chair is about 1:7, with the seat slightly flaring out in the front. The curve of the ellipse of the top portion is repeated in a smaller scale in the cut out "flying bird" as well as in the support stretcher between the back legs.

Hill House Chair, Charles Rennie Mackintosh, 1902

Wealthy Glasgow publisher Walter Blackie was impressed with Mackintosh's design of the Glasgow School of Art and approached him to design a house for his family. Blackie's sensibilities favoring simplicity and scale rather than Victorian ornamentation matched those of Mackintosh. The commission was one that allowed Mackintosh to fully engage his ideas and sharp eye for detail, and Hill House became Mackintosh's largest and most refined house.

The Hill House chair seems delicate and tall due to the narrow ladder-back and bottom to top repetition of rungs. It was not designed for seating but rather to serve as a visual divider between two areas in the master bedroom. Walls and all other furnishings in the master bedroom were all painted white and the chairs stood out for their dark ebonized finish and graphic geometry. Similar to the Argyle chair, the back of the Hill House chair terminates at a "decorative" element, in this case a gridded lattice.

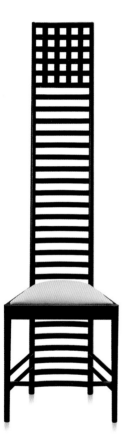

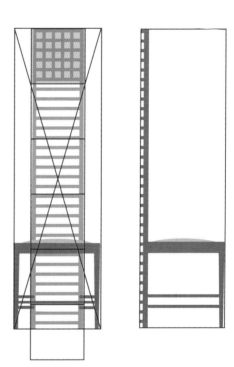

69

Hill House Chair Proportions
The narrow long back of the chair and ladder struts that run all the way to the floor make the Hill House chair seem even taller. The proportion of the ladder-back portion of the chair is 1:11. The height of the chair can be described by a series of squares and the number 5. The height of the chair is 5.5 squares, based on the width of the ladder back, and there are 5.5 rungs in each square. The top grid pattern consists of 5 x 5 small squares.

Willow Tea Room Chair, Charles Rennie Mackintosh,1904

The Willow Tea Room was another expansion of Kate Cranston's business empire, and was the most luxurious by far. By this time a mutual relationship of trust and admiration had developed between Cranston and Mackintosh and he had sole responsibility for the architecture, interiors, and furnishings. The result was modern architecture and luxurious interiors the like of which had never been seen in Glasgow. Customers and the curious flocked to the new tea room, which won praise and admiration.

The Willow Tea Room chair is one of the most exquisite of Mackintosh's furniture designs. It was designed as a lattice divider between the front ladies tea room and back dining room, and was used as a desk chair for the tea room manager who would take orders from the waitresses. The geometric lattice back abstractly echoes a willow tree while providing a degree of separation of the front of the tea room and the back. Other fixtures in the room also used the grid pattern but none so elegantly.

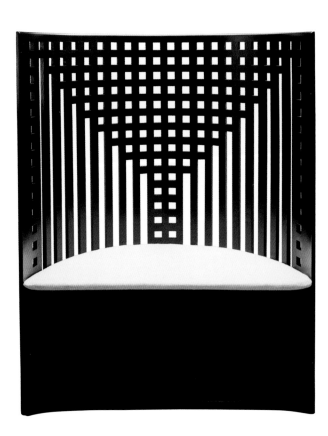

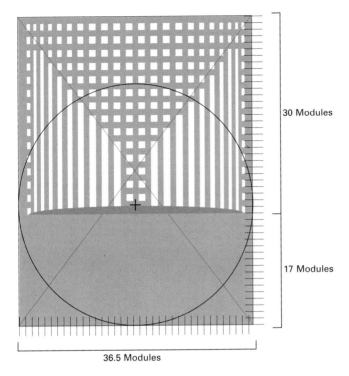

30 Modules

17 Modules

36.5 Modules

Willow Tea Room Chair

The scale and shape of the chair are imposing. The curve of the lattice back is close to a semicircle and the pure geometry of the grid pattern creates a satisfying repetition and contrast of right angles to the arc. The semicircle of the chair stands alone in the furnishings of the room with the grid squares tying it to the other chairs, decorations, and architecture.

The proportions of the chair are based on the arc of the circle. The chair is designed with the upholstery at the center point of the circle placed over the front view.

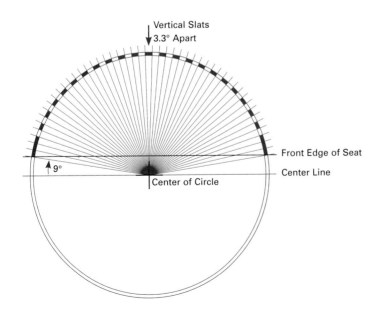

Vertical Slats
3.3° Apart

Front Edge of Seat

Center Line

9°

Center of Circle

Bauhaus Ausstellung Poster, Fritz Schleifer, 1922

Fritz Schleifer celebrated the tenets of Constructivism in his 1922 *Bauhaus Ausstellung* (Bauhaus Exhibition) poster. As per the Constructivist ideals of the time, the human profile and the typography are abstracted into simple geometric shapes of the mechanical machine age.

The geometric face, originally designed as part of a Bauhaus seal by Oskar Schlemmer, is further reduced from Schlemmer's original to five simple rectangular shapes by eliminating the fine horizontal and vertical lines. The width of the smallest rectangle, the mouth, is the module of measure for the width of the other rectangles.

The typography is designed to be consistent with the same rectangular elements as the face. It echoes the rigid angular forms. The typeface is similar to an original face designed by Théo van Doesburg in 1920.

72

Bauhaus Seal, Oskar Schlemmer, 1922

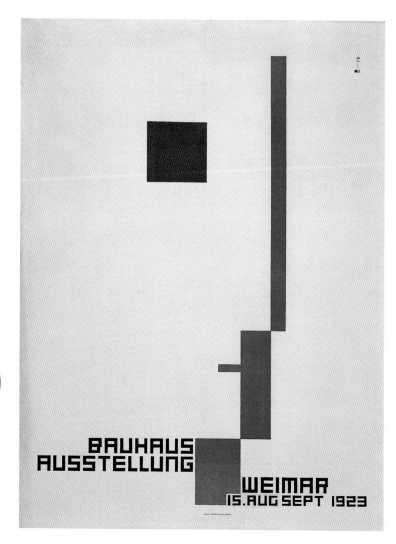

Type Design

The type structure is based on a 5 unit by 5 unit square, which permits the widest characters, M and W, to occupy a full square with each stroke and counterform occupying a unit. The narrower characters occupy a 5 x 4 portion of the square, again with each stroke occupying a unit and the counterforms enlarged to two units. The B and R deviate in that a concession of 1/2 unit is made to the rounded forms and to distinguish the R from the A and the B from the number 8.

Analysis

The eye aligns along the center vertical axis. The other facial elements are placed in asymmetric relationship to this axis. The type aligns top and bottom with the neck rectangle.

Rectangle Width Proportion

Mouth
Head, Nose
Chin
Neck
Eye

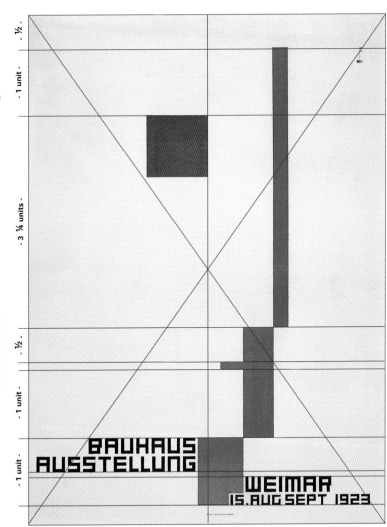

73

L'Intransigéant Poster, A. M. Cassandre, 1925

"The mathematically expressed module can only act to confirm a spontaneous insight. The golden rule merely defines the ideal proportion previously intuited by the artist; it is a means of verifying, not a system (it would be doomed [if it were], like every system)."
Diary, Adolphe Mouron, 1960

The *L'Intransigéant* poster designed in 1925 by Adolphe Mouron, who was more widely known as

A. M. Cassandre, is both a conceptual triumph and a study in geometric construction. The poster is for a Parisian newspaper, *L'Intransigéant*, and the conceptual triumph is the translation of the representational form of a woman's head into the visual symbol of Marianne, the voice of France.

Cassandre was educated as an artist and studied painting at a number of studios in Paris. Indeed, he

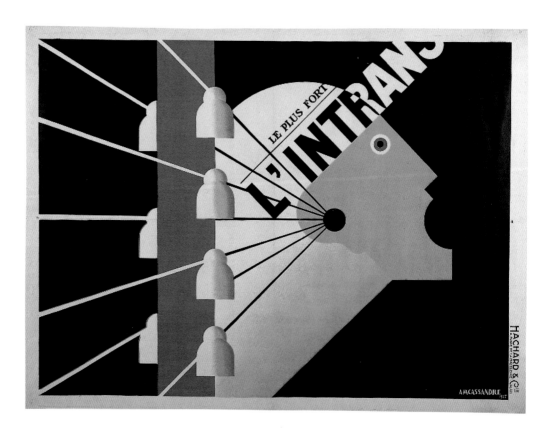

74

took the pseudonym Cassandre with the idea that when he returned to painting that he would do so under his given name, Adolphe Mouron. Very soon, however, he became fascinated by poster art and found that it held more potential for dynamic experimentation than did painting for him. The idea of mass communication was appealing as well as the idea of an art that crossed the traditional and entrenched boundaries of class distinction.

Because of his interest and studies in painting, Cassandre was deeply influenced by Cubism. In an interview in 1926 he described Cubism: "...its relentless logic and the artist's endeavors to construct his work geometrically bring out the eternal element, the impersonal element beyond all contingencies and individual complexities." He acknowledged that his work was "essentially geometric and monumental," and the elements of geometric con-

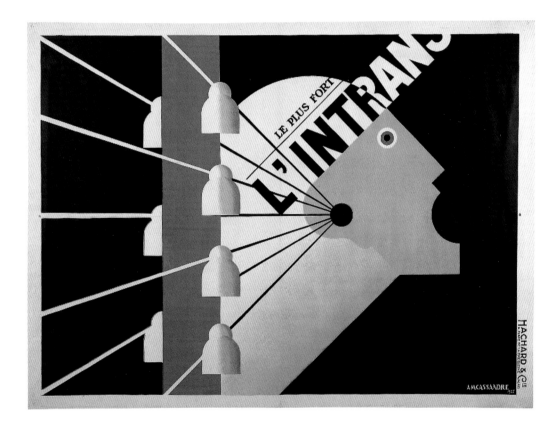

Grid Analysis

The poster format is organized into a series of modules 6 x 8, yielding a total of 48 square visual fields. All elements of the poster correspond to this plan in terms of placement and proportion. The inner ear is at the intersection of these visual fields as is the center of the mouth. The corner of the "L" lands in the exact center of the poster. The chin of the figure fits into a visual field, as does the width of the telegraph pole. The 45° angle of the neck moves from corner to corner of a square of four visual fields. The telegraph wires begin at the ear center and move at 15° increments forming again 45° angles above and below the horizontal.

struction can be found in almost all of his posters. In particular Cassandre was very conscious of the compelling visual power of the circle and consciously used the circle in this poster and many other posters to direct and focus the viewer's attention.

In addition to fine-art Cubism, the poster movement called Sach Plakat, or the object poster, influenced Cassandre's work. The object poster movement departed from the expressive and embellished work of the past with objectivity and function as the primary goals. This philosophy was echoed by the Bauhaus in the 1920s and can be seen repeatedly in Cassandre's posters throughout his career. In *L'Intrans* the newspaper is reduced to just a portion of the masthead that overlaps a more powerful symbol, Marianne, the voice of France.

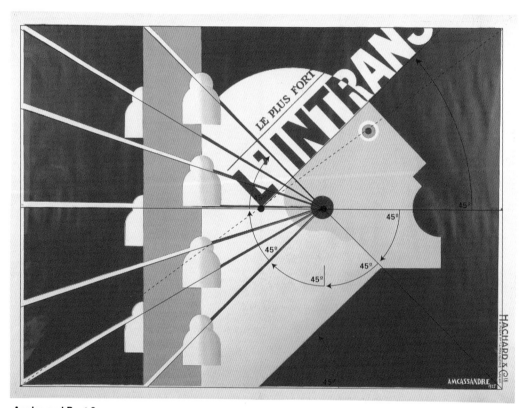

Angles and Root 2
The format of the poster is a root 2 rectangle. The eye is bisected by the diagonal of the root 2 rectangle, shown with a dashed line. This diagonal also bisects the center of the poster at the lower left corner of the "L." The baseline of the word, L'INTRANS, is at a 45° diagonal from the center of the poster. The telegraph wire lines are arranged at approximately 15° increments which yield the 45° module that is repeated in the nose and neck angles.

Circle Diameter Ratios

head circle	= 4 mouth circles
mouth circle	= outer ear circle
mouth circle	= 2 1/2 small ear circles
inner ear circle	= eye circle
inner ear circle	= insulator circles
inner ear circle	= ear lobe circle

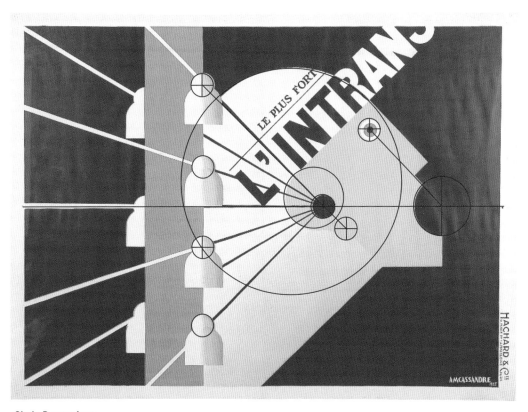

Circle Proportions

The outer ear and mouth circles are the diameter of one visual field. The smaller circles of the eye, inner ear, ear lobe, and insulator have a diameter of two fifths of a visual field. The largest circle, the head, has a diameter of four visual fields.

The placement of the circles is organized so that the center points of circles on the head are aligned on 45° diagonals. The insulator circles are all aligned on diagonals at approximately 15° increments. Three of these 15° increments yield the 45° module.

East Coast by L.N.E.R. Poster, Tom Purvis,1925

Tom Purvis' 1925 poster, *East Coast by L.N.E.R.*, is an invitation to the viewer for summer vacation travel on the London Northeast Railroad. More than twenty-five years earlier two designers who called themselves the Begarstaffs experimented with the then radical approach of developing powerful compositions of flat areas of color defining simplified graphic silhouettes. Purvis' poster uses a similar technique of simplification and play of space, color, and pattern.

The umbrella ellipse is the most powerful and compelling visual force in the poster, not only because of the vibrant color but also because of the shape and diagonal placement. The bright orange is in complimentary contrast to the blue sky and water. The elliptical shape is close to the shape of the circle, which attracts more visual attention than any other geometric form. The diagonal direction is the most provoking visual direction due to its instability

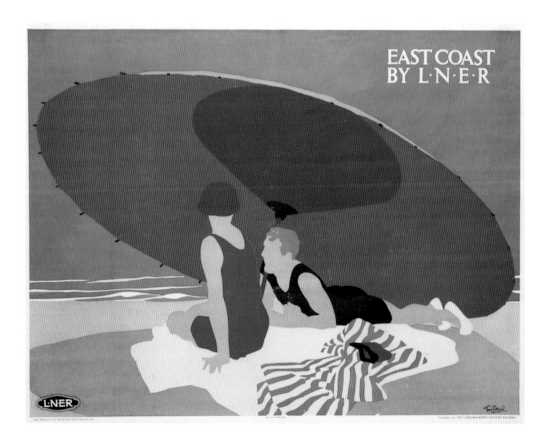

and implied motion. The dramatic ellipse is repeated two more times in the interior structure of the umbrella and in the black pole support.

All of the shapes are simple silhouette shapes created with great economy of detail. The striped texture and casual arrangement of the towel provides a change in texture from the simple shapes.

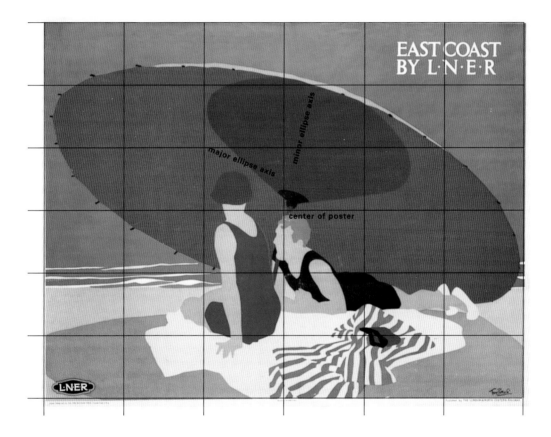

Analysis

The poster is readily analyzed by means of a 6 x 6 grid. The horizon line of the sky and water divides the poster and occupies the top two thirds. The minor ellipse axis of the orange umbrella passes through the center of the poster and balances the composition. The interior darker orange ellipse is the same proportion as the large umbrella. The figures rest left and right of this axis providing a balance of color and shape.

MR Chair, Mies van der Rohe, 1927

During the mid-1920s Mies van der Rohe was influenced by others who were experimenting with the new technology of tubular steel in furniture design. Metal was not a new material and iron had been used in mid-nineteenth-century furniture for cast-iron garden furniture, rocking chairs, and tubular steel for children's furniture and hospital beds. Metal was cost-effective, readily bent, and easily cleaned. It was rarely used for home interiors because of the aesthetic sensibilities of Victorian

tastes for upholstery with carved and embellished wood, and because of the unyielding coolness of the metal to the touch. What was new was the simplicity and geometric style of the way Mies used the metal.

By the early 1920s at the Bauhaus, Marcel Breuer had experimented with tubular steel in the design of tables, chairs, desks, and storage uinits. In 1925 as the Bauhaus moved from Weimar to Dessau,

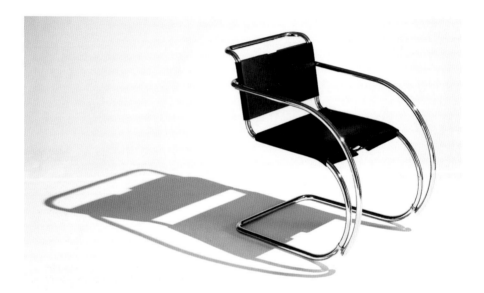

80

MR Chair Influences

1850, Peter Cooper, Iron Rocking Chair (left)
The sled-style frame is solid cast iron and the MR chair design is similar.

1860, Thonet Rocking Chair #10 (right)
The frame is similar to the Iron Rocking Chair and made with bentwood. Interestingly, the MR chair was at one time manufactured by Thonet.

Breuer designed a range of furnishings for the new buildings, with the most iconic and lasting design being the ground breaking tubular steel chair, the elegant Wassily chair.

Mies was aware of Breuer's work and also that of Mart Stam who had designed a cantilever chair frame of right angles from straight lengths of gas pipe and elbow connectors. Mies's chair frame was cantilevered, similar to Stam's, but instead of right angles the chair frame used a curve of tensioned tubular steel. This curve created an elastic frame that bent with flexible tension and provided comfort without the addition of an upholstered cushion. The chair was available in leather and canvas, which were laced on with ties, and cane upholstery that was woven around the frame. In the early armchair version caning was wrapped around the arms so that the arms of the user did not touch cold metal.

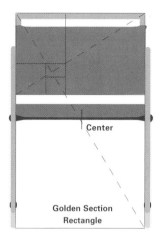

MR Chair, Front View
The MR chair front view fits in a golden section rectangle and the center point of the rectangle is at the seat.

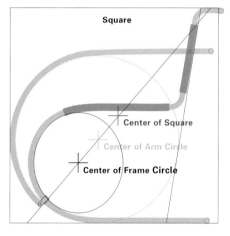

MR Chair, Side View
The MR chair side view fits in a square. The center point of the square, center of the arm circle, and center of the frame circle all align on the same diagonal. The slope of the chair back is tangent to the arm circle.

1925, Marcel Breuer, Wassily Chair (left)
Made from tubular steel with stretched leather upholstery

1926, Mart Stam's Chair (right)
Rough drawing of the cantilever chair frame made of straight gas pipe and elbow connectors

Barcelona Chair, Mies van der Rohe, 1929

The Barcelona Chair was designed in 1929 for the German Pavilion at the International Exhibition in Barcelona, Spain. The pavilion was unlike any of the others in that it did not contain any exhibits; the building itself was the exhibit. Elegant, sparse, and consisting of travertine marble, gray glass, chrome columns, and dark green marble, the building's only furnishings were Barcelona Chairs and Barcelona Ottomans upholstered in white leather, and Barcelona Tables. The ottomans and tables used a support "x"

frame similar to the chair. Mies van der Rohe designed the building and the furniture, and both are considered milestones of design as well as the greatest achievement of Mies's European career.

It's difficult to believe that such a contemporary, classic piece was designed and produced more than eighty years ago. The Barcelona Chair is a symphony of meticulous proportions based on a simple square. The height of the chair is equal to the length which is

82

Chair Proportions (right)
The chair side view (top right) as well as front view (bottom right) fit perfectly into a square. The divisions of the back cushion approximate small root 2 rectangles.

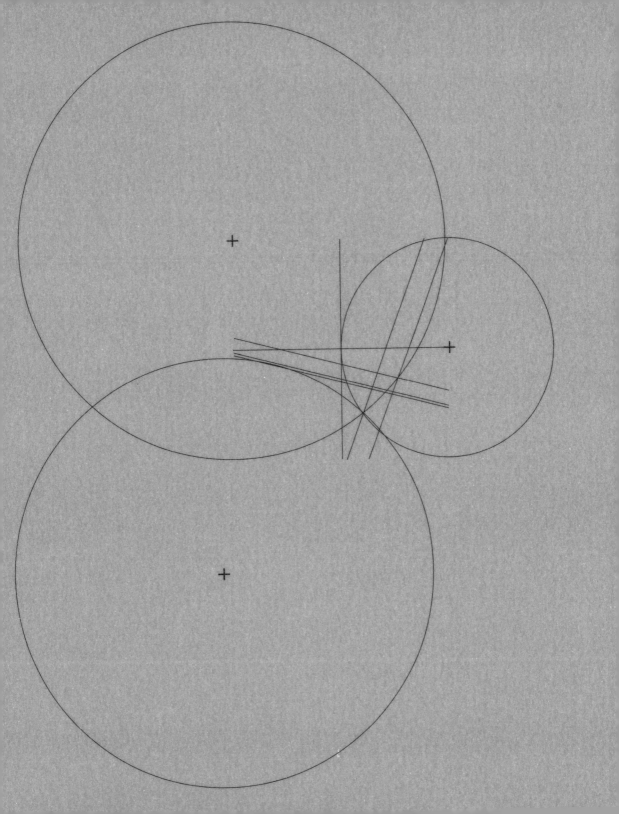

equal to the depth, i.e, it fits perfectly into a cube. The rectangles of leather on the cushions are in root 2 rectangle proportion attached to a steel frame. The same rectangles were designed so that when the chair was upholstered they would still be perfect rectangles despite the stress and tension of the upholstery process. The script "x" construction of the legs form an elegant frame and lasting trademark for the chair.

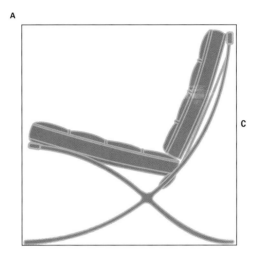

A

C

B

Curve Proportions

The primary curve of the chair back and front leg is formed by a circle with the same radius as the square, with center point A. The curve of the original circle is repeated on the front of the seat support with an identical circle with center point B. Another circle, with one-half the radius of the first, defines the back leg with center point C.

Chaise Longue, Le Corbusier, 1929

Architects educated in the Beaux-Arts tradition often are very aware of the principles of classical proportion, and involve these principles both in the architecture and furniture that they design. Le Corbusier is one of these architects and the attention to detail and proportion in his architecture can also be found in his Chaise Longue. Le Corbusier was influenced in the 1920s by other architects such as Mies van der Rohe who were designing tubular steel furniture for their buildings. Both Le Corbusier and Mies were influenced by the geometric forms of Thonet Bentwood furniture and used simplified similar forms in their own work.

In 1927, Le Corbusier began a collaboration with Charlotte Perriand, a furniture and interior designer, and his cousin, Pierre Jeanneret. The collaboration was highly successful and lead to a number of classic furniture designs that bear Le Corbusier's name, including the Chaise Longue.

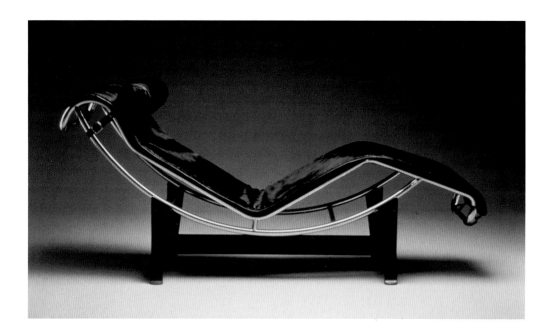

Predecessor of the Chaise Longue
The Thonet reclining rocking chair, ca. 1870

The chrome tubular frame of the Chaise is an arc runner that rests on a simple black stand. This arc is an elegantly simple system that slides in either direction and allows the user an infinite variety of positions, and is held in place by friction and gravity with either the head or feet raised. Similar to the geometric arc frame, the pillow is also a geometric form of a cylinder that is easily repositioned by the user. The arc of the frame is such that the frame can be removed from the stand and used as a reclining rocker.

Analysis
The proportions of the chaise relate to the harmonic subdivisions of a golden rectangle. The width of the rectangle becomes the diameter of the arc that is the frame of the chaise. The stand is in direct relationship to the square in the harmonic subdivision. The Chaise Longue is analyzed by a harmonic decomposition of a golden section rectangle.

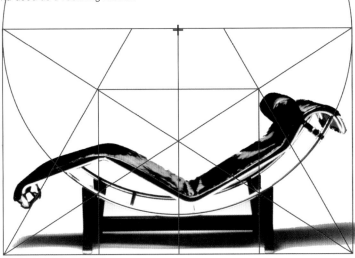

85

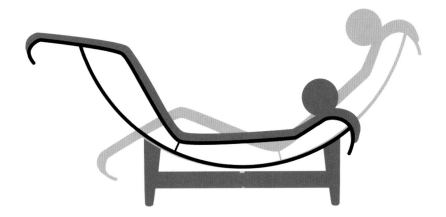

Brno Chair, Mies van der Rohe, 1929

Mies van der Rohe received a commission to design a family residence for the Tugendhat family based on his highly acclaimed architecture for the Barcelona Pavilion in 1929. In addition, he was asked to design furniture for the residence that would be in keeping with the stark modernism of the building.

Mies had successfully developed a cantilever armchair, the MR Chair, in 1927. At the time the technology of bending tubular steel was new and presented innovative design options. The design of the MR Chair was based on earlier nineteenth-century designs of tubular iron rockers and the celebrated Bentwood Rocker by Michael Thonet. Because of the strength of tubular steel the frame of the MR Chair was cantilevered and the design simplified.

The Tugendhat house had a large dining room and a table that could seat 24. The MR Chair was originally specified for this purpose but was awkward as a din-

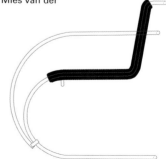

Predecessors of the Brno Chair
Thonet Bentwood Rocker, ca. 1860 (left), side view of the MR Chair, Mies van der Rohe, 1927 (right)

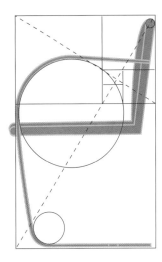

ing chair because the extended arms did not fit under the table. The Brno Chair, named after the town of Brno where the Tugendhats lived, was designed for this purpose and the low sweep of the arms and compact form fit neatly under a dining table. The original chairs were upholstered in leather and the design was executed in both tubular steel and flat bar versions, which resulted in structural variations.

Analysis

The top view fits perfectly into a square (above right). The front view of the chair (right) and side view (far right) fit neatly into a golden section rectangle. The angle of the front legs and chair back (below right) are symmetrical, and the radii of the curves are in 1:3 proportion.

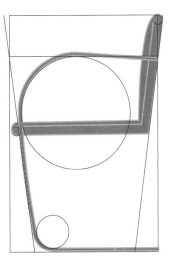

Wagon-Bar Poster, A. M. Cassandre, 1932

"Some people call my posters Cubistic. They are right in the sense that my method is essentially geometric and monumental. Architecture, which I prefer above all others, has taught me to abhor distorting idiosyncrasies...I have always been more sensitive to forms than to colors, to the way things are organized than to their details, to the spirit of geometry than to the spirit of refinement..."

Adolphe Mouron, A. M. Cassandre, *La Revue de l'Union de l'Affiche Française,* 1926

The *Wagon-Bar Poster* is no less a marvel of geometric interrelationships than is the earlier *L'Intrans*. Again, Cassandre selects representational elements to be simplified and stylized into simple geometric forms. The seltzer bottle, wine and water glasses, loaf of bread, wine bottle, and straws are placed in front of a photograph of a train wheel.

The diameter of the wheel becomes the measure of the railroad track segment that emphasizes

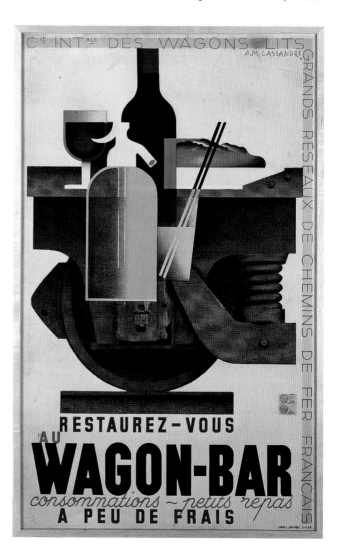

88

"RESTAUREZ-VOUS" and "A PEU DE FRAIS." The center of the poster is visually punctuated by the ends of the two straws in the drinking glass. The poster is easily divided into thirds on the vertical.

The geometry of the drawn images is apparent in the shoulders of the bottles and the bowl of the wine glass. There is a beautiful play of space as the white background of the poster bleeds into the siphon top of the seltzer bottle. A similar change of space occurs

with the bread loaf and the wine bottle label as well as the top of the glass and the edge of the wheel casing.

This poster is relatively complex in the number of elements that require geometric simplification, structural interrelationships, and organizational control. Yet upon analysis it is clear that there is a reason for each and every decision.

Analysis

Conscious placement and control of each element is evident in the center points of the circles that form the wine glass bowl and the shoulders of the seltzer bottle as they land on the diagonal from the upper left corner to lower right corner. Likewise, the center of the wine bottle circle and the wheel center align on the same vertical.

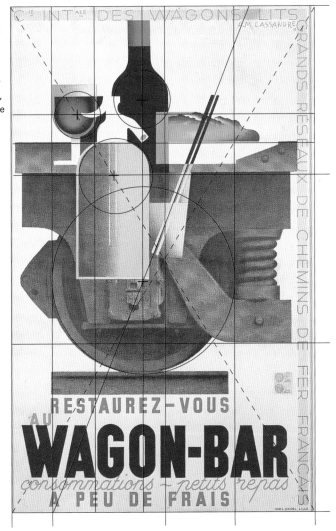

89

Konstruktivisten Poster, Jan Tschichold, 1937

"We do not know why, but we can demonstrate that a human being finds planes of definite and intentional proportions more pleasant or more beautiful than those of accidental proportions."
Jan Tschichold, *The Form of the Book*, 1975

This poster, created by Jan Tschichold in 1929, was for an exhibition of Constructivist art. Since this poster was created at a time when the Constructivist movement was dissipating, the circle and line can be interpreted as a setting sun. The Constructivist art movement mechanized fine art and graphic design via mathematical placement of abstracted geometric elements as a functional expression of industrial culture. As a poster, this work utilizes the Constructivist ideals of geometric abstraction, mathematical visual organization, and asymmetric typography as advocated in Tschichold's book *Die Neue Typographie*, published in 1928.

Analysis

The diameter of the circle becomes a unit of measurement for the poster and placement of the elements. The circle itself is a focal point and the eye is inexorably pulled toward it. The circle also highlights the title of the exhibition as well as the list of exhibitors. The small bullet next to the line of text with the dates of the exhibition repeats the circle and is an element of visual punctuation as it echoes to and contrasts in scale with the major circle. The list of exhibition contributors begins at the meeting point of the diagonals of the poster format and the diagonal of the bottom rectangular section. The distances of the text to major elements are modules of the distance from the horizontal line to the base line of "konstruktivisten," which is centered in the circle.

Compositional Triangle

The typography of the poster forms a triangle which serves to anchor it to the format and enhance visual interest.

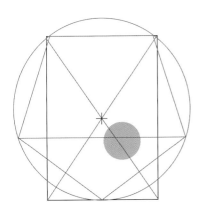

Format Proportions

The narrow rectangular format is a pentagram page and is derived from a pentagon inscribed in a circle. The top surface of the pentagon becomes the width of the rectangle and the bottom point the bottom of the rectangle. The horizontal line in the poster is placed so as to connect two of the vertices of the pentagon.

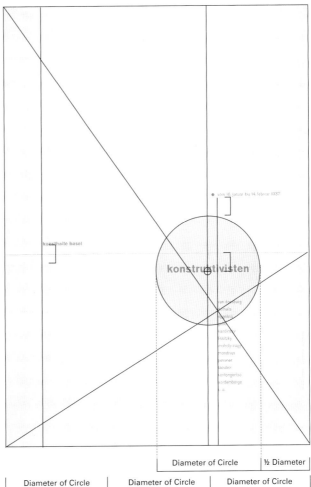

Diameter of Circle | ½ Diameter

Diameter of Circle | Diameter of Circle | Diameter of Circle

Barrel Chair, Frank Lloyd Wright, 1904, 1937

Similar to Mies van der Rohe, Frank Lloyd Wright designed furniture specifically for his buildings. Both architects believed in honoring the architecture with furnishings appropriate for the unique style and harmonizing the interior with the exterior.

In the early twentieth century Wright was designing and building modern homes in a style that hadn't been seen before. Flowing horizontal lines, abstracted geometry, and simplicity in the architecture required furnishings with a similar aesthetic. Many of the furnishings available at that time were ornate and inappropriate for such modern architecture. Influenced by the Arts and Crafts movement, the design of the furnishings gave Wright the opportunity to fully acknowledge the architecture with interior furnishings as well as a venue for increasing his fees and profits through the additional commission of furniture design services.

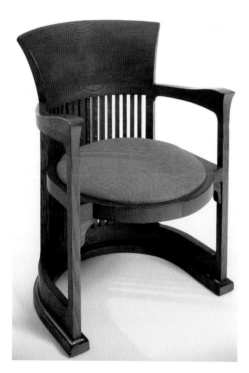

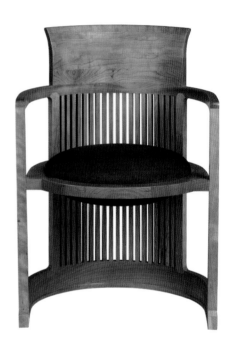

Original Barrel Chair, 1903
The early version of the Barrel Chair had flared arms that terminated in a pointed angle. The base was broad and accented with moulding and small brackets supported the seat. The chair back was thick and flared back from the arms.

Refined Barrel Chair, 1937
The Refined Barrel Chair has a simplified frame. The flared arms have been tapered to a straight line that terminates in a radius. The back support is less thick, narrower, and extends straight up from the arms to a slight flare. The base is also simplified without the extra moulding.

The Barrel Chair, a favorite of Wright, was originally designed in 1904 and was refined and used in the Taliesin dining room in 1925, and in Fallingwater in 1935. In 1937, when Wright was designing Wingspread, a house for Herbert Johnson of the S. C. Johnson Company, he needed chairs for the dining room and he again revisited and further refined the Barrel Chair. The proportions were adjusted, the arms simplified, and the base was tapered, which resulted in a more streamlined and cohesive design.

Many of Wright's furniture designs involved rectangular planes with angles, and the Barrel Chair stands out because of the curved back and use of the circle. The cushion punches through the seat and can be seen above and below the wood frame. From the side view the seat circle cantilevers beyond the arms, reminiscent of a number of Wright's buildings. The chair back slats continue from the back support to the base giving an effect of enveloping and shielding the user.

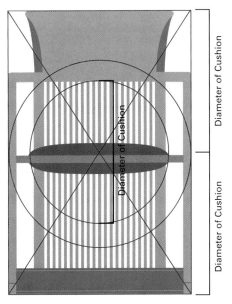

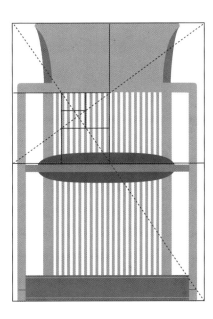

93

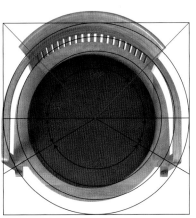

Barrel Chair Proportions
The Refined Barrel Chair has pleasing proportions. The front view fits in a root 2 rectangle with the seat frame just below the center point. The arms of the chair are at one half the distance from the seat to the top of the chair back. The height of the chair is twice the diameter of the cushion, and the repeated wood slats terminate at the top of the cushion circle, above left. The chair back occupies 1/4 of the circle or 90°, left, and the arms occupy 2/3 of the circle or 240°.

S. C. Johnson Administration Building Chairs, Frank Lloyd Wright, 1938

Frank Lloyd Wright was a genius not only in the practice of architecture but also in his ability to persuade his clients to accept and fund unconventional ideas in architecture and furniture design. When he was designing and building the S. C. Johnson Administration Building in Racine, Wisconsin, he insisted that the furnishings had to echo the geometric circles and curves of the architecture. Despite considerable resistance due to budgetary problems, he prevailed.

The chair shown below is the original design from the 1937 Patent Office drawings. It had cantilever arms, three legs, and a series of repetitive supports from the bottom of the frame to the seat. Similar to the seat of the Barrel Chair, the chair back and seat were upholstered on both sides, allowing the cushions to appear to flow through the frame. The metal frame was made of a solid aluminum bar in a cruciform or + shape.

Feb. 15, 1938. F. L. WRIGHT Des. 108,473

CHAIR

Filed Dec. 20, 1937

94

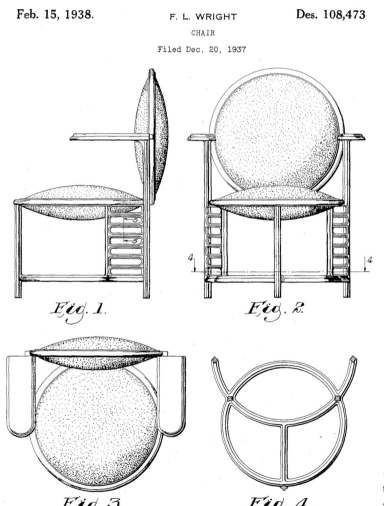

Fig. 1. Fig. 2.

Fig. 3. Fig. 4.

1937 Patent Office Plans for the S. C. Johnson Administration Building Chair

The chair that went into production was a far less costly and more refined version from the 1937 Patent Office drawings. It was made with tubular steel instead of solid aluminum and refinements were made by both Wright and the newly formed Steelcase furniture company, who manufactured the chair. The profile of the chair became slightly narrower, with simplified supports and casters. In the armchair version the arms were simplified with a single wood slat and were strengthened with an angled support from the mid-point of the arm to the back leg frame. The back of the chair pivoted for the comfort of the user, and in a nod to economy, both the back and seat cushions could be turned entirely as the upholstery became worn.

By far the most unusual furnishing was the three-legged office chair. Although the design met with resistance, Wright argued that the three legs would enable the user's feet to be more comfortably positioned beneath it, and that the chair would promote good posture as it required

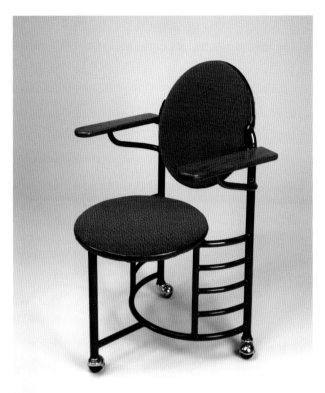

Three-Legged Chair for the S. C. Johnson Administration Building

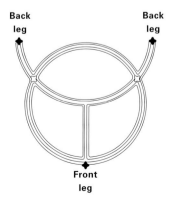

Back leg · Back leg · Front leg

Three-Legged Chair
The bottom of the chair frame changed in material and design. The solid aluminum cruciform frame, left, was replaced by tubular steel, right. The design changed from the original "Y" with an intersecting circle, left, to the simpler "Y," right.

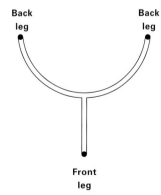

Back leg · Back leg · Front leg

both feet to be on the ground in order to be stable. Until users acclimated to the unusual design there were falls from the chair, purportedly even Wright himself. While he maintained that the users would benefit from the chair, he did design a four-legged version, the Officer's Chair, for the executives who were probably less willing to adjust to the design than the office staff.

In addition to the chair, Wright designed a unified series of desks, file cabinets, and credenzas for the S. C. Johnson Administration Building. The furnishings all featured steel tube frames and the curves reflected the circles, curves, and cylinders of the building structure. The geometry in all of the furnishings is unmistakable with pure circles punctuated by straight lines and radius edges. The constraints of reducing the costs of manufacturing and mass producing the furnishings greatly benefited the design by simplifying and standardizing the components and shapes.

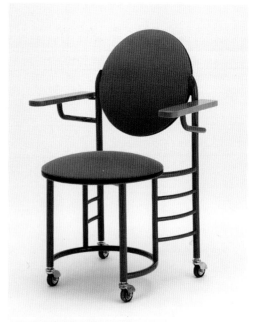

Officer's Chair

Production Version, Officer's Chair
The frame of the chair fits in a golden section rectangle with the seat and back fitting into the square of the rectangle. The circle is repeated in the back, seat, and frame. The lower frame supports align with the golden section construction diagram.

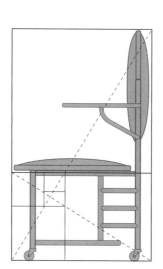

Width = 3 units

Height = 5 units

Three-Legged S. C. Johnson Administration Building Chair and Desk

Officer's Chair and Desk

Der Berufsphotograph Poster, Jan Tschichold, 1938

This 1938 poster by Jan Tschichold was for an exhibition of the work of professional photographers and is a classic in concept and composition after many decades. Because of the exhibition content, the image of a woman is representational but also abstracted in that she is portrayed as a film negative. This technique focuses the viewer's attention on the process of photography rather than on a single image of a woman. The main title, "der berufsphotograph," is printed as a split font, whereby three different colors of ink, yellow, red, and blue, are placed on a printing roller and "mix" as the roller turns. This rainbow of color in the typography is a rare expressionist departure from the formalism of Tschichold's other work. However, his love of asymmetric and functional typography are evident in the layout of carefully aligned and related typographic elements and textures.

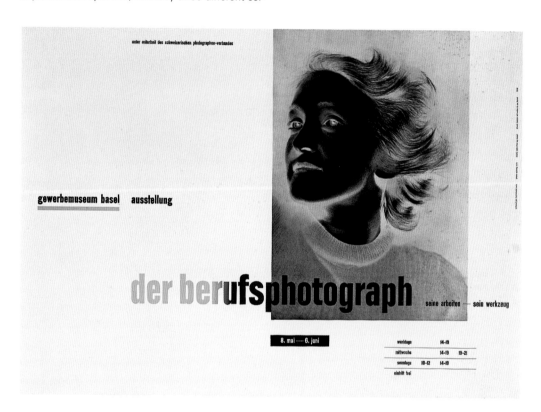

Root 2 Rectangle Relationships

The root 2 construction diagram is placed on top of the poster. The corner of the reciprocal and the diagonals bisect the eye of the figure in the photograph.

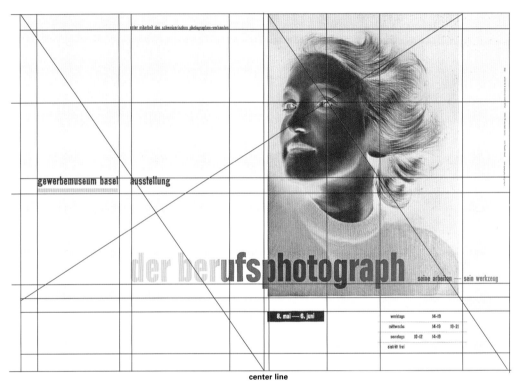

center line

Analysis

The negative photograph is just to the right of the center of the root 2 rectangle format. The left eye of the figure is carefully placed and the image cropped so as to become the nexus of diagonals that regulate the placement of elements. The measure of the width and depth of the image is echoed by the typographic elements to the left.

Max Bill Font, Max Bill, 1944

"I am of the opinion that it is possible to develop an art largely on the basis of mathematical thinking."
Max Bill, from a 1949 interview, *Typographic Communications Today*, 1989

Max Bill was distinguished as a fine artist, architect, and typographer. He studied at the Bauhaus under Walter Gropius, Moholy-Nagy, and Josef Albers, among others. At the Bauhaus he was influenced by

the ideals of functionalism, De Stijl, and formal mathematical organization. The hallmarks of the 1920s De Stijl included a very formal dividing of space with horizontal and vertical lines. Bill's use of geometric abstraction was developed to include typographic elements as well. The letter forms are hand generated and based on the root 2 rectangle. Each typographic character has a direct geometric relationship to the structure of the root 2 rectangle

Root 2 Letter Form Construction
The root 2 rectangle defines the structure of the letter forms. The square determines the x-height and the remainder portions the length of either the ascender or descender.

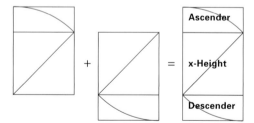

and is created in modular form. There are some lovely quirky aspects to the font such as the backwards "n," an "m" that is composed of two touching "n" shapes, and angles in the "s." The font was used for a poster designed in 1944 and again for a poster and exhibit that Bill designed in 1949.

Type Construction

The construction square of the rectangle is the base line and mean line or x-height of the lowercase font. The ascenders and descenders are defined by the length of the root 2 rectangle. The strokes are based on geometric construction with angles restrained to 45°. Deviation of the angles occurs in the "s" with 30° and 60° construction, and in the major strokes of the "a" and "v" with 63° angles. Two root 2 rectangles are used to create the "m" which is two repeated "n" shapes. The numbers are created with the same construction methods, utilizing a perfect circle, which reflects the larger circle shapes in the composition.

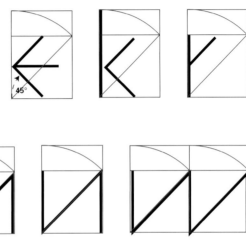

Farnsworth House, Mies van der Rohe, 1945–51

To Dr. Edith Farnsworth, who commissioned it, the house was a weekend retreat in the country away from the concrete and stress of the city as well as a reason to spend time with a brilliant architect. To Mies van der Rohe, who designed it, the house was an ultimate expression of Modernist architecture. The wooded riverfront site was level and perfect for the house that Mies envisioned, and what began as a shared vision, and possibly romantic collaboration, ended in court. Cost overruns escalated out of control and the beautiful house was difficult to enjoy as it was excessively hot in the summer and difficult to heat in the winter.

The house is composed in Modernist sculptural elements. Rhythms are created with the column supports and windows moving the eye along the length. Horizontal planes shift and overlap in space as they rise above the ground on steel columns, and the house appears to float above the earth in space.

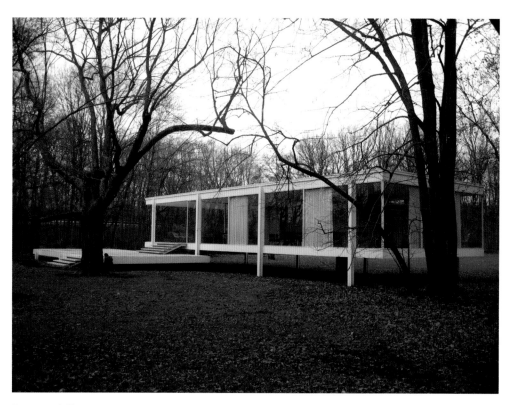

Farnsworth House

The roof of the house cantilevers over an outdoor deck providing shade and capturing the space as part of the house. The outdoor space is extended in the sun through a lower platform and the rhythm of the wide low stairs invites the visitor. As visitors approach, the house appears to hover above the ground, rising six feet above the flood plane on steel beam stilts.

The house proved to be too far ahead of its time to be comfortable for Dr. Farnsworth. During cold Illinois winters, the heat that radiated from the floor system met cold glass and condensation formed, pouring down the windows. The summer sun radiated through the walls of glass and made the house almost impossible to cool, and the outdoor deck spaces were rarely enjoyed due to mosquitoes.

South Elevation

Open Deck

Covered Deck

Entry Steps

6'

Square

Square

Square

Golden Section Rectangles

The space between the series of support columns is the width of a golden section rectangle. Overhang of the roof, left and right, as well as the smaller pane of glass is roughly equivalent to the width of one of the smaller squares in the golden section rectangle construction diagram.

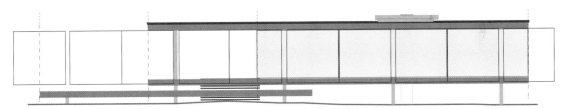

Repetition of Squares

The expansive windows are a series of squares. Two squares describe each pane and smaller panes are half the width of the square.

Plywood Chair, Charles Eames, 1946

Although he had a full scholarship to study architecture, Charles Eames left college after two years at Washington University in St. Louis. The curriculum was based on the traditional principles of the École des Beaux-Arts, which clashed with his avid interest in modernism and the work of Frank Lloyd Wright. However, throughout his life he appreciated the foundation that the Beaux-Arts training had given him in the classical principles of proportion and architecture.

His Plywood Chair was designed for an Organic Furniture Competition sponsored by the Museum of Modern Art in 1940. Eames and his collaborator architect Eero Saarinen sought to bring organic forms together into a unified whole. As a result the beautiful curvilinear forms caught the eye of the judges, as did the innovative technologies of three-dimensional molded plywood and a new rubber weld technique that joined the plywood to metal. The entry won first place.

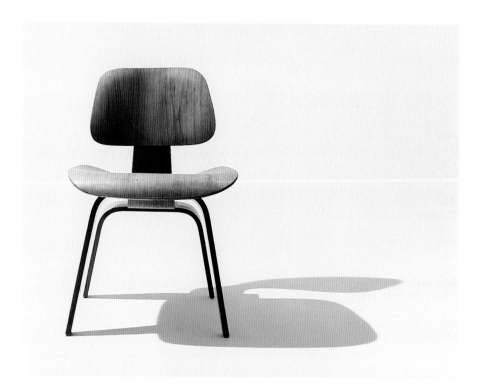

Plywood Chair
All plywood version (above) and plywood and metal version (right). The chair was made in two designs; a lower lounge chair version and a slightly higher dining chair version.

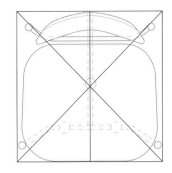

The current chair, still in production, evolved from that winning entry. It is impossible to state unequivocally that the relationship of the chair's proportions to the golden section rectangle were fully consciously planned, but the classical Beaux-Arts training, as well as the collaboration with Eero Saarinen, make this assumption highly likely.

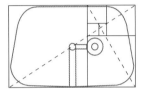

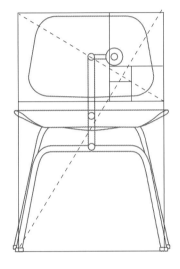

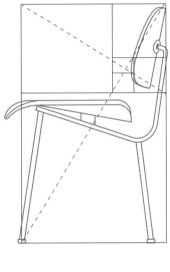

Chair Back (above)
The chair back fits perfectly into a golden section rectangle.

Chair Proportions (right)
The dining chair proportions are roughly those of the golden section.

Chair Detail Proportions
The radii of the corners of the chair back as well as the tubular legs are in proportion to each other 1:4:6:8.

A= 1
B= 4
C= 6
D= 8

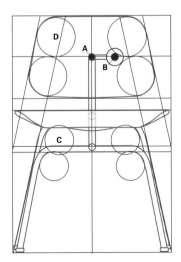

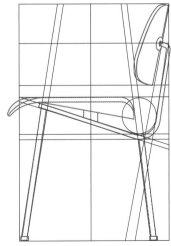

Philip Johnson Glass House, Philip Johnson, 1949

Philip Johnson's family was wealthy and could indulge him with prolonged trips to Europe while he was studying history and philosophy at Harvard. It was during these trips that he became interested in architecture and in 1928 met with Mies van der Rohe, who was designing the German Pavilion for the Barcelona International Exposition. The meeting was pivotal for Johnson, who began a lifelong friendship and, eventually, collaboration. Later, as the first curator of architecture at the Museum of Modern Art he curated the ground-breaking show "The International Style: Architecture Since 1922," which introduced modern architecture to America.

Dissatisfied with his work as a journalist and curator, in his 30s he returned to Harvard to enter the Graduate School of Design. The Glass House was an opportunity for him to establish himself as a professional architect of note and to put his education and ideas into practice. The result was a stunning glass-walled structure of meticulous proportions and details. The shocking transparency of the house is emphasized by the lack of interior walls and the ability to look both within and out. Only a brick cylinder, containing a bath and fireplace, rises from the floor and pierces the ceiling. The world of architecture was on notice, Philip Johnson had arrived.

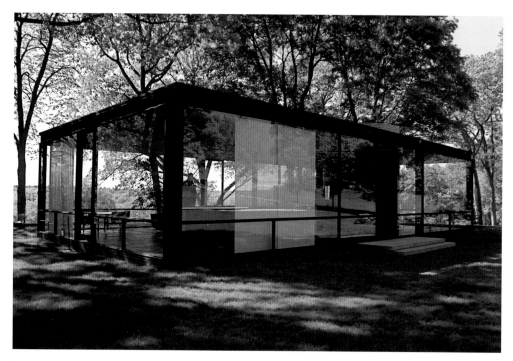

Philip Johnson Glass House
The Glass House was Johnson's master's thesis project at Harvard in the early 1940s. After graduation he continued developing the house design and in 1945 he bought a five-acre wooded site in New Canaan, Connecticut. Construction began in 1948 and was completed in 1949.

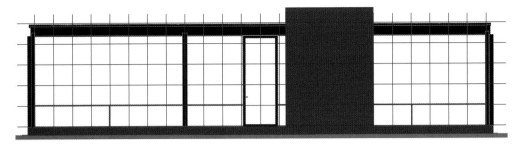

East Elevation Proportion

The front facade of the house fits in a square grid, 5 x 24. The lower windows are 1 x 4 and next to the door 1 x 3 units. The door is 2 units wide. The brick cylinder contrasts in form with the right angles of the structure and is asymmetrically placed to the side of the door.

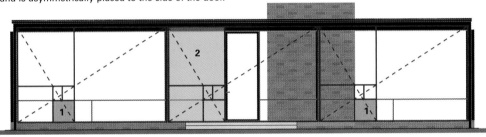

East Elevation Golden Section Proportions

Each of the three divisions of the house, separated by steel vertical columns, is in golden section proportion. In each division the square of a reciprocal golden section rectangle fits inside the lower horizontal window, 1. In the center division a reciprocal golden section rectangle fits in the windows to the left and right of the door, 2.

North Elevation Golden Section Proportions

The north elevation is also in golden section proportion. Shown are two overlapping golden section rectangles in red and blue. As in the east elevation the square of the reciprocal golden section rectangle, 1, fits inside the lower window and the edge lands at the window division. The two golden section rectangles overlap at the square of the reciprocal golden section rectangle and are the width of the door, 2.

Door

Bedroom
Area

Partition

Bath and
Fireplace
Cylinder

Main
Entry
Steps

Door

Gravel
Path

Living
Area

Door

Pedestal

Kitchen
Area

108

Dining

Door

Golden Section Proportions
The plan view of the Glass House
is close to golden section propor-
tion, shown in red. Doors are
placed symmetrically by center-
ing on each exterior wall. Living
spaces are separated from the
bedroom area by a low partition
wall. The kitchen space is defined
by a row of low cabinets housing
appliances and storage.

Furnishings
As a nod to his friend, mentor, and collab-
orator, Mies van der Rohe, the living area
furnishings are Barcelona chairs, otto-
man, table, and chaise. The dining chairs
are Brno chairs—all designed by Mies.

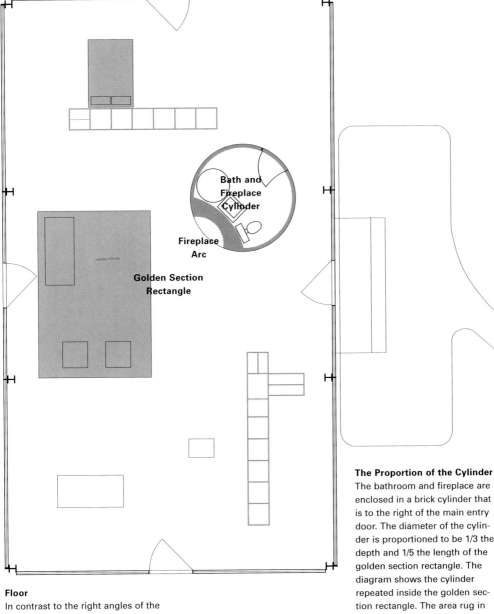

Bath and Fireplace Cylinder

Fireplace Arc

Golden Section Rectangle

Floor

In contrast to the right angles of the structure and smooth textures of black steel and glass, the floor is red brick that is laid in a herringbone pattern. The brick creates a subtle texture, binds the structure to the earth, and is in concert with the bath and fireplace brick cylinder.

The Proportion of the Cylinder

The bathroom and fireplace are enclosed in a brick cylinder that is to the right of the main entry door. The diameter of the cylinder is proportioned to be 1/3 the depth and 1/5 the length of the golden section rectangle. The diagram shows the cylinder repeated inside the golden section rectangle. The area rug in the living room space is about the width of the cylinder and 1.5 the length of the diameter of the cylinder. The diameter of the arc of the fireplace is 50 percent of the diameter of the cylinder.

Illinois Institute of Technology Chapel, Mies van der Rohe, 1949–52

Mies van der Rohe is best known for his monumental architecture of steel and glass skyscrapers. He was a master of proportioning systems and many of these skyscrapers are so similar in form and proportion that they can be classified as a single archetype. Mies was the Director of the School of Architecture at the Illinois Institute of Technology for twenty years, and during that time he designed the entire campus and many of the buildings on it.

The IIT chapel is a good example of his use of proportioning on a smaller scale. The entire building facade is in the proportion of a golden section, 1:1.618, or roughly 3:5. The building is also perfectly subdivided into five columns by golden rectangles, and when those rectangles are repeated in a pattern, the building is a module of 5 x 5 horizontal rectangles.

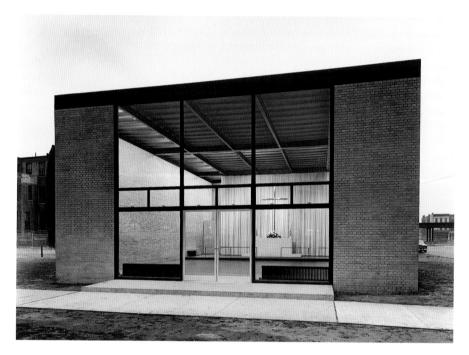

Illinois Institute of Technology Chapel
Exterior view of the front facade (above)
and interior view (right)

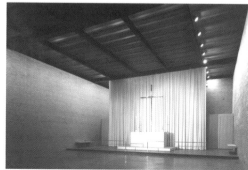

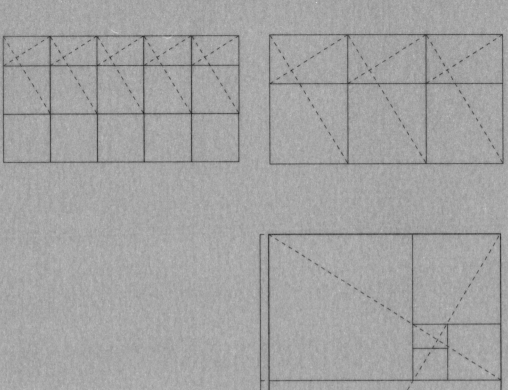
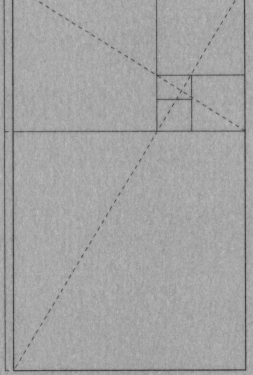

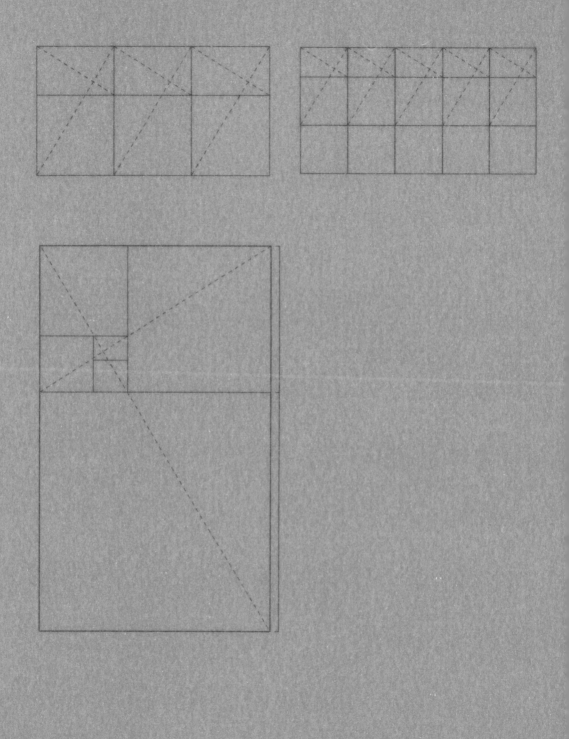

Exterior Front Elevation

Front Elevation Section

Golden Section Proportions

The golden section proportion can readily be seen in these drawings (top left). The front facade of the chapel can be subdivided into a series of golden section rectangles that surround the top large windows and smaller top hung ventilator windows. The bottom windows are squares with double doors in the center square.

The section drawing of the interior looking towards the altar shows that the perimeter of the front facade can be defined by three golden section rectangles (top right).

The plan of the chapel perimeter fits perfectly into a golden section rectangle. The square of the golden section rectangle defines the area for the congregation and the reciprocal golden section rectangle defines the altar and service and storage areas of the chapel. These two areas are separated by a small elevation of the altar area and railing. The original plan of the chapel had no seating; however, seating was added later (right).

The photograph at left is from the 1950s. Sadly, in recent years this building has suffered from inaccurate window replacement and poor repair. Visitors to the site should not expect to find the building as shown.

111

Tulip Chair, Eero Saarinen, 1957

Eero Saarinen's love of simplicity and unified forms can be seen in his architecture, such as the Gateway Arch in St. Louis, Missouri, as well as in his furniture design of the Tulip Collection. Saarinen had collaborated earlier with Charles Eames on the design of the Plywood Chair, and his quest for truly unified organic forms was brought to fruition with the Tulip Collection in 1957.

Saarinen sought to simplify interiors and eliminate what he considered the disarray of table and chair legs. The forms were so sleek, modern, and unexpected that they became icons of the future.

The side chair version of the Tulip Collection is shown here and is part of a group that includes stools, arm chairs, and side tables. The front and side views of the chair fit comfortably into golden section proportions and the pedestal curves bear a relationship to the golden section ellipse.

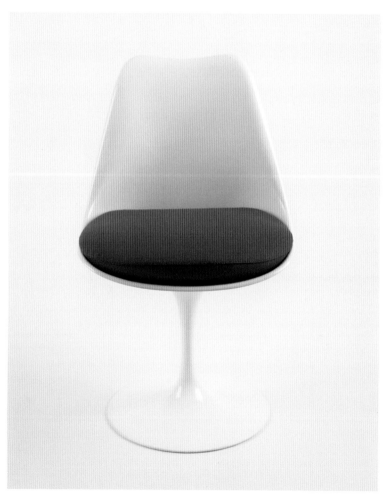

Golden Ellipse

Similar to the golden rectangle, the ratio of the major axis to the minor axis of the golden ellipse is 1:1.62. There is also evidence that the human cognitive preference is with an ellipse of these proportions.

Analysis

The front view of the chair fits easily into golden section proportions (right). The front view can also be analyzed as two overlapping squares: the bottom square meeting the top of the seat cushion and the top square meeting the joint of the pedestal to the seat.

The major chair pedestal curves to conform readily to the golden ellipse proportions at both the top and bottom.

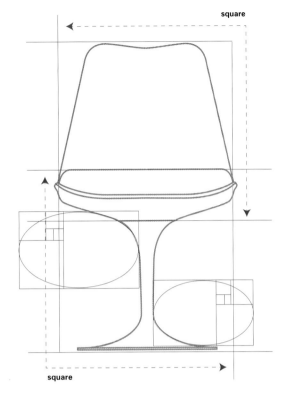

square

square

Side and Front Views

Both the side (right) and front views (far right) of the Tulip chair fit comfortably into a golden section rectangle. The front lip of the chair is at the center point of the golden rectangle. The base as it attaches to the seat of the chair is about 1/3 the width.

113

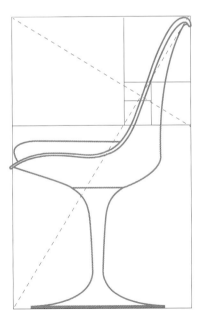

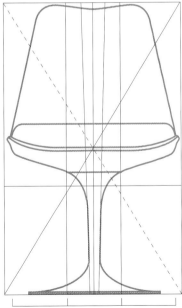

Vanna Venturi House, Robert Venturi, 1962–64

Breaking with the starkness of modern architecture and Mies van der Rohe's statement that "less is more," Robert Venturi argued the case for eclecticism in architecture by declaring that "less is a bore." In the small house he built for his mother he experimented with many of the ideas he would write about later in his influential book, *Complexity and Contradiction in Modern Architecture*. These ideas included the use of complexity, ambiguity, and contradiction.

The house is at first simple and boldly symmetrical in its reflected gable roof line, centered chimney, and dominant square entry. Yet the eye is fascinated with the off-center chimney top, asymmetric window arrangement, and the presence of a rectangular void that seems to be punched through the center of the structure. The strong diagonals of the roof and right angles of the windows are brought together in harmony with the single artistic stroke of a circular arc.

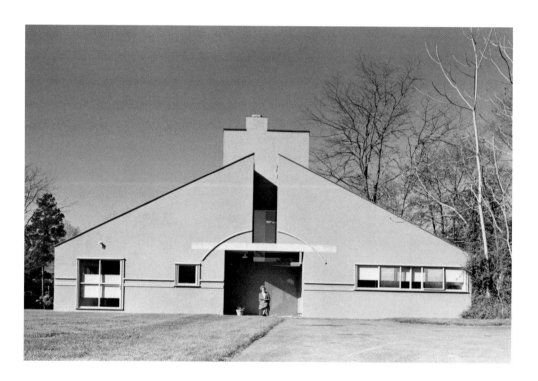

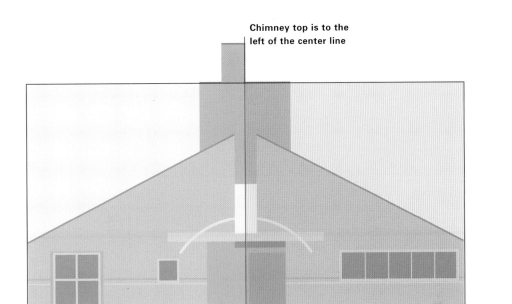

Center
Line

Proportions of the Vanna Venturi House
The proportions of the house, with the exclusion
of the chimney top, are 1:2. The main proportions
of the house including the roof line and doorway
are symmetrical.

Circles and Alignments
The circle segment above the entrance
gives some clues as to how the various
elements of the house relate to each
other. A series of circles, all with the
same center point, touch on the archi-
tectural elements.

115

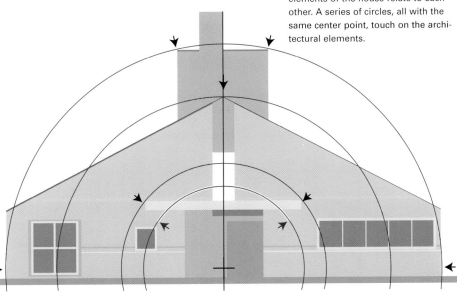

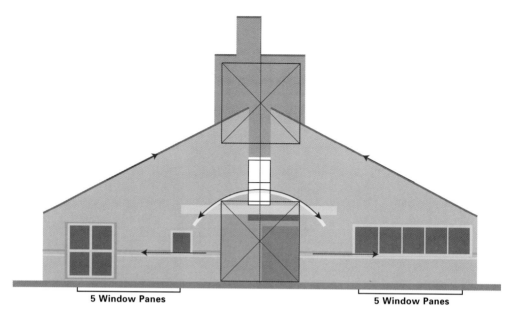

5 Window Panes 5 Window Panes

Asymmetry and Direction

The configuration of the windows is different on the left and right sides of the house. The left side consists of four windows clustered in a square pattern plus a single window near the entry. The right-side windows are all horizontal on a single row. Although the size of the windows is different, the shape and number of panes is the same.

One of the most pleasing aspects of the house is the way the eye moves. The dramatic angle of the roof line moves the eye up and toward the chimney. The repeated square of the chimney is a visual pause the allows the eye to move down. The circle segments above the doorway bring the eye down with the lintel and horizontal lines move the eye out both left and right.

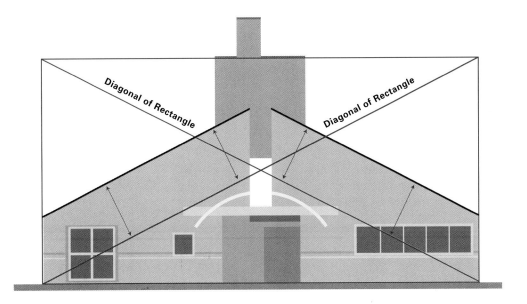

Diagonals and Diagonal Grid

There are strong relationships between the diagonal of the roof line and the structure. When the 1:2 proportion rectangle is placed over the facade of the house the diagonals of the rectangle are parallel and repeated in the roof line. Repetition of the diagonals in a grid pattern, below, shows the relationships between the elements and a series of alignments of the main architectural features.

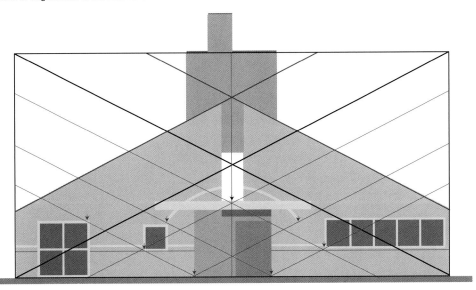

Vormgevers Poster, Wim Crouwel, 1968

This poster was created in 1968, long before the advent of the personal computer and digital typography. At this time only banks were heavily involved in computer processing and the typeface of this poster has a similar aesthetic to a face of machine-readable numbers found in cheque books. The typography of the poster is both reminiscent of this early computer-readable type and also highly prophetic of the coming digital age. Even then Wim Crouwel envisioned that the screen and computer would play an ever expanding role in typographic communication.

The poster format is in root 2 format, with a square grid pattern, and very simply divided in half. The grid pattern is more complex in that each square is subdivided by a line that is placed one fifth of the distance from the top and right side of the square. The letter forms are "digitally" created, using squares from the grid pattern. The offset grid lines determine the radius of the corners and the same radius is used to link the strokes.

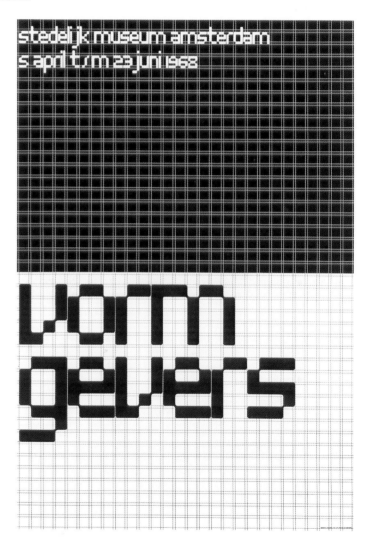

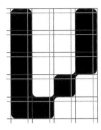

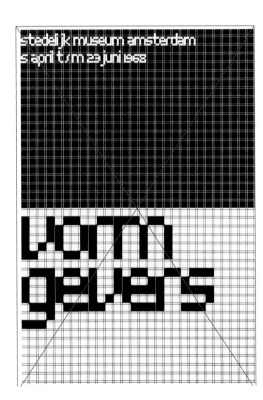

Analysis

The system of construction of the letter forms is based on the use of a grid shown in the diagrams with a red line. The harshness of the square grid is softened by the use of radii that correspond to offset lines placed 1/5 the distance from the top and right of each grid square shown in the diagrams with a gray line. The grid allows for the "digital" creation of horizontal, vertical, and diagonal strokes. The alphabet is single case and letters only have hairline separation in between. Most letter forms are created in a 4 x 5 pattern. Narrow letter forms such as the i and j only occupy the width of one grid square. The text at the top of the poster is 1/5 the size of the text at the bottom.

Fürstenberg Porzellan Poster, Inge Druckery, 1969

Inge Druckery fluidly communicates the fineness and delicacy of Fürstenberg porcelain with this poster. The letter forms are thin, geometric constructions of a single weight, and the curvilinear letter forms, particularly the u and r, are asymmetric compositions of harmony and timeless elegance.

As with most twentieth-century European posters, this one is in the standard root 2 display format, and the elements have a relationship to root 2 construction. The vertical and horizontal center lines meet as the viewer's eye follows the vertical stroke of the number "1" as it approaches the apex of the upper-case "A."

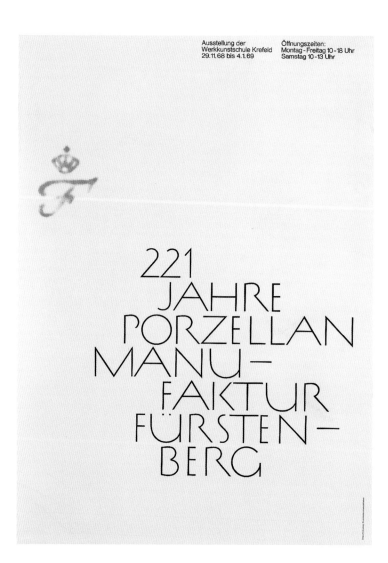

Letter Form Construction

The set width of the characters is based on a square divided into thirds. The narrowest letter forms occupy one-third, slightly wider two-thirds, and still wider a full square. Finally, four-thirds are used for the widest characters.

Analysis

The constructed letter forms for "221 JHARE PORZELLAN MANUFAKTUR FÜRSTENBERG" have a height of about 1/16 the depth of the poster. The three lines of the small set type at the top are two-thirds of the depth of the constructed letter forms. The porcelain makers mark, an italic F and crown, is twice the size of the letter-form construction square.

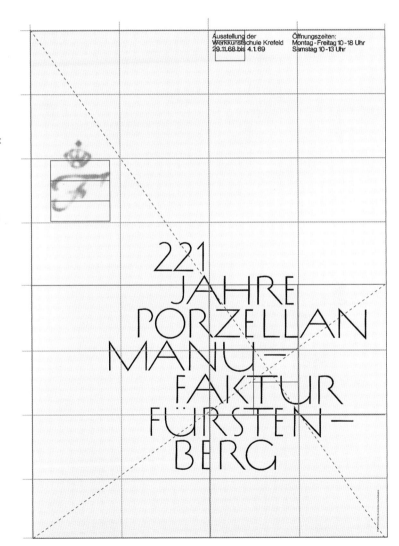

Munich Olympics Pictograms, Otl Aicher, 1972

Pictogram systems for the international Olympic Games were not new as such systems had been developed as a cross-cultural visual language and used for the games since the 1936 Berlin Olympics. In 1967 Otl Aicher was named as the lead designer for the 1972 Munich Olympic Games. The job was complex as there was a need for over 150 pictograms for the athletic events and a multitude of communication materials including logos, schedules, programs, uniforms, posters, etc.

Aicher's approach to the pictogram design was to create an abstracted system of stylized geometric forms. The basic shapes of head, torso, arms, and legs were arranged on a grid of vertical, horizontal and 45° diagonal lines. The scale of the elements of human body parts was systemized and the forms were composed in poses reminiscent of the sport. The diagonal grid gave the pictogram figures dynamic poses that suggested action. The result is a lasting pictogram series that is still in use today.

Fencing Pictogram
© 1976 by ERCO GmbH,
www.aicher-pictograms.com

Running Pictogram
© 1976 by ERCO GmbH,
www.aicher-pictograms.com

Equestrian Riding Pictogram
© 1976 by ERCO GmbH,
www.aicher-pictograms.com

Bicycling Pictogram
© 1976 by ERCO GmbH,
www.aicher-pictograms.com

Soccer Pictogram
© 1976 by ERCO GmbH,
www.aicher-pictograms.com

The Aicher pictograms are composed of standardized geometric shapes representing the human form. The head is a circle and the arc of that circle is used as a radius to smooth transitions from the shoulder to the arm. The limbs are rectangles of a consistent width, which are bent at the elbows or knees, and hands and feet are reduced to semicircles whose diameter matches the width of the rectangle.

All of the figures are arranged in a square format and the position in the square is a logical placement according to the sport. Standing figures, such as the Running pictogram fill the frame top to bottom. The bent over Bicycling figure rides a bicycle positioned at the bottom of the square, and the Equestrian rider seated on a horse is at the top of the square.

Equipment is also abstracted to simple shapes and represented by a thin stroke as in the rapier of the Fencing figure, the Bicycling circles, and the horse in the Equestrian figure. A thin line extends from the head circle in the Equestrian pictogram to become the bill of the jockey's cap, and a white line through the head of the Fencing pictogram suggests the mask.

Geometric System

The shapes for all of the figures are consistent. Circles for head, hands, and feet. Rectangles for arms, legs, and torso. The radii of the bent shoulder, elbow, and knee, are of the same arcs as the circles. The separation of the torso from the legs becomes a negative space "belt" in almost all of the figures.

123

LEB, London Electricity Board, FHK Henrion, 1972

Frederick Henry Kay (FHK) Henrion emigrated from Germany to Britain in 1939. During World War II he designed posters and communications for the British Ministry of Information and for the U.S. Office of War Information. His reputation grew as his posters became familiar to the British public.

In the early 1950s he established his own design consulting firm, Henrion Design Associates, and soon developed a strong reputation as a pioneer in corporate identity design and marketing research. His firm successfully tackled very large and visible projects for British Leyland automotive, Olivetti, and BEA and KLM airlines. His reputation spread and in 1967 with Alan Parkin he published *Design Co-ordination and the Corporate Image*, a pivotal book on corporate identity design featuring international case studies as well as his firm's own highly successful systematic research driven approach.

LEB Corporate Identity
In Henrion's mind consistency was one of the hallmarks of successful corporate identity design. The LEB logo is drawn on an isometric grid so that over time the identity could be redrawn accurately in any size for any use. Likewise, the application of the identity was also consistent in applications to a wide range of business communications including application to vehicles.

Identity Construction from the LEB Corporate Identity Manual

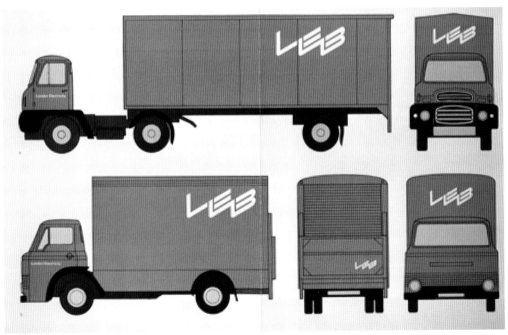

Identity Application to Vehicles from the LEB Corporate Identity Manual

Majakovskij Poster, Bruno Monguzzi, 1975

Bruno Monguzzi recaptures the spirit of the early Russian Constructivists in this poster for an exhibition of work of Russian artists in Milan. The design of this poster reflects the revolutionary ideals of Russian Constructivism of the 1920s. The use of restrained colors, red, black, and gray, and the bold rectangles at a 45° angle give the poster a feeling of visual utilitarianism that was the hallmark of the Constructivists.

Monguzzi uses the same sans-serif typography and utilitarian techniques of the Constructivists with a keen compositional eye. Hierarchically, the prominent names of the three artists, Majakovskij, Mejerchol'd, Stanislavskij, are the major visual force. The rules and typography are in the same proportion. A sense of visual space is communicated by the overlapping rules and transparency is created by the red rule overlapping the gray with resulting color change.

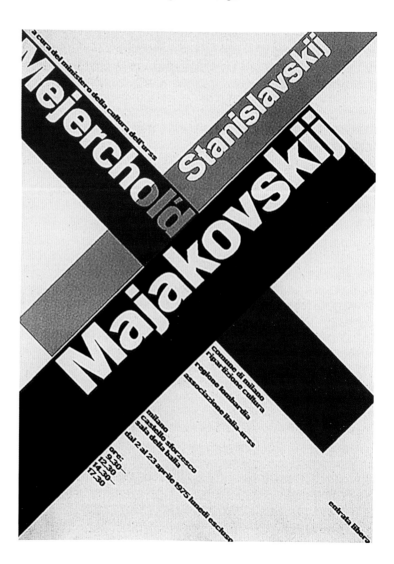

Proportional Elements

The width of the rules that the typography is reversed out of is 2:3:4. The typography is synchronized with this proportioning and is also in the proportion of 2:3:4.

Root 2 Format

The circle construction method for the root 2 rectangle reveals the centered "x" that dominates the composition.

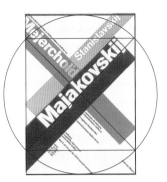

Analysis

The three overlapping rules are in a proportion of 2 (brown):3 (red):4 (black) and the cap height of the typography follows the same proportional system. A 90° corner of each rule meets the edge of the format to create a strong sense of visual tension.

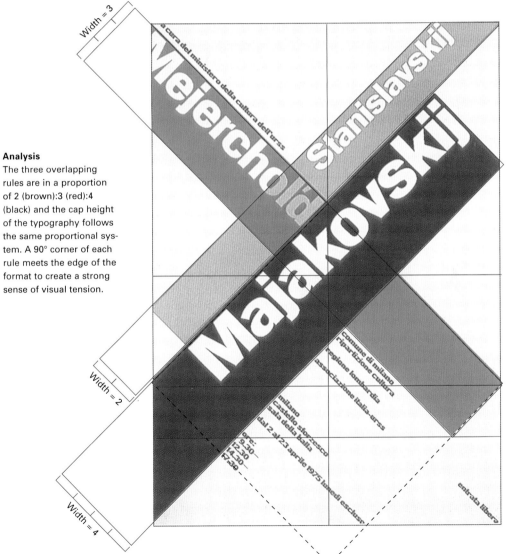

Braun Handblender, 1987

The simple and elegant design of Braun appliances has made them a favorite of artists, architects, and designers. Many pieces are included in the permanent design collection of the Museum of Modern Art. The Braun forms are almost always clean, simple, geometric shapes in white or black with simple controls. The simple lines of the design give each appliance the visual feel of a functional piece of sculpture.

The industrial designers of these three-dimensional works of art employ similar systems and develop similar interrelationships as their graphic design counterparts. Because of the three-dimensional qualities the interrelationships are both visual and structural.

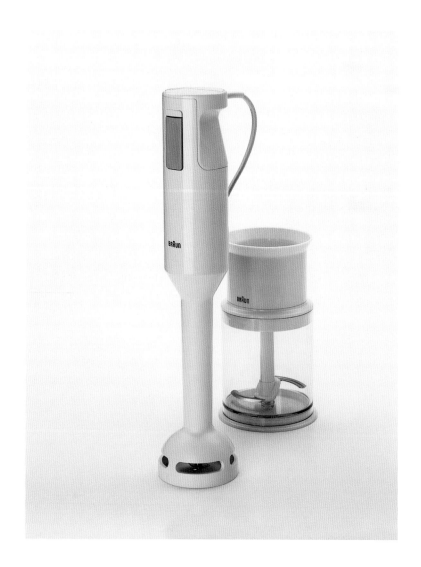

Structure and Proportion

The measure of the long shaft of the handblender is one-half the total height of the appliance. The radii details of the button and surfaces are similar sizes and are shown on the diagram as red circles. There is a symmetry to the surface and even the placement of the corporate name, Braun, is tightly controlled in relationship to the other elements by being centered and having a cap height similar to the diameter of the red circle.

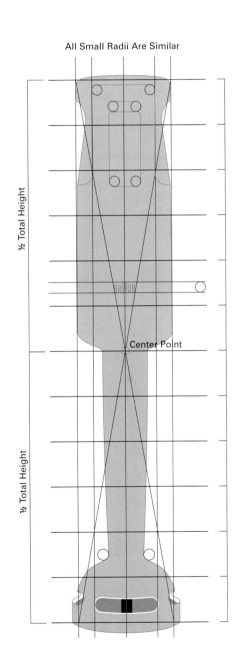

All Small Radii Are Similar

½ Total Height

½ Total Height

Center Point

129

Braun Aromaster Coffee Maker

The Braun coffee maker also has a similar sense of "rightness" to its form. The forms remain geometric and the cylinders are accented by a handle that is almost a pure circle. Again, the corporate name, Braun, is given the same attention to detail, scale, and placement as are all of the other elements. The combination of visual organization of two- and three-dimensional forms causes this appliance to transcend the utilitarian to become a work of sculpture.

130

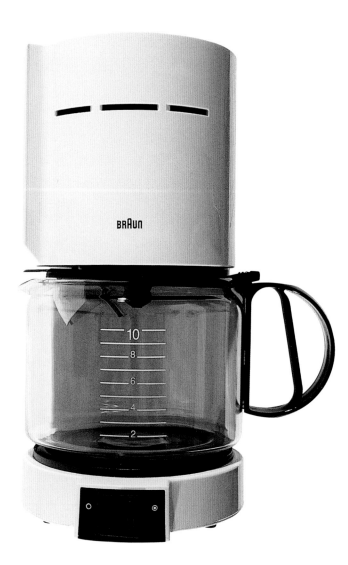

Structure and Proportion

The surface of the coffee maker can be divided into a regular series. Each surface element is carefully planned to be in harmony with all others. The logotype, Braun, is slightly above the center. The cylindrical shape of the coffee maker is in keeping with the shape of the handle, which is a segment of a circle. The diagonal of the handle aligns with the top corner. The symmetry of elements can be seen in the fasteners on the switch that align with the measure marks on the pot as well as the center vent opening on the top.

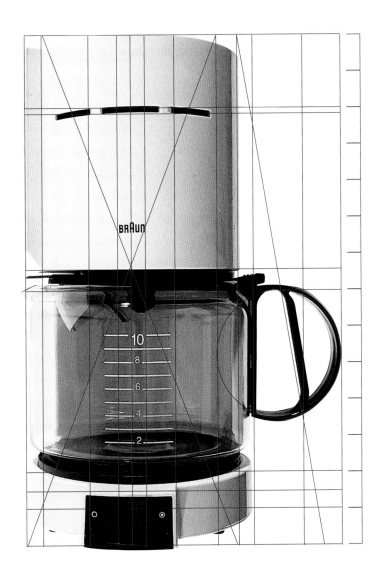

131

Il Conico Kettle, Aldo Rossi, 1980–83

The Italian design manufacturer Alessi has long been known for attracting and producing the work of experimental cutting edge industrial designers. The products are as much art as they are design and so, too, is the Il Conico kettle by Aldo Rossi. Rossi's approach is that of a conceptual artist who creates the concept for the product and then turns to the production technicians to resolve production process and details under his direction.

The kettle is a unified composition of geometric solids. The main kettle form is a cone of an equilateral triangle that permits the bottom surface to maximize contact with the heat source and allow for efficient heating. The form of the kettle readily breaks down into a 3 x 3 grid. The top third of the kettle, the vertex, is a delightful small sphere. This sphere makes removing the top easier, but also acts as a form of three-dimensional punctuation for the vertex of the

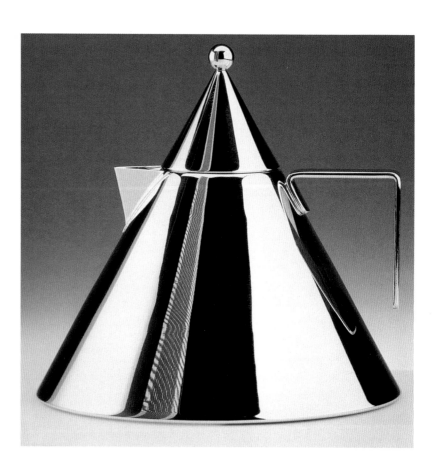

kettle. The middle third of the kettle consists of the spout and handle. The handle extends out horizontally from the pot and then down vertically. This handle shape can be viewed as an inverted right triangle or a portion of a radius square. All of the primary geometric shapes are part of the composition: cone, triangle, circle, sphere, and square.

Dominant Form

The dominant shape of Il Conico is the cone derived from an equilateral triangle. The handle is an inverted right triangle, one half of an equilateral triangle, and can also be viewed as a portion of a square.

Geometric Structure

The kettle can readily be analyzed with a 3 x 3 grid. The top third is composed of the lid and sphere handle, the middle third the spout and kettle handle, and the wide bottom base permits the maximum contact with the heating surface.

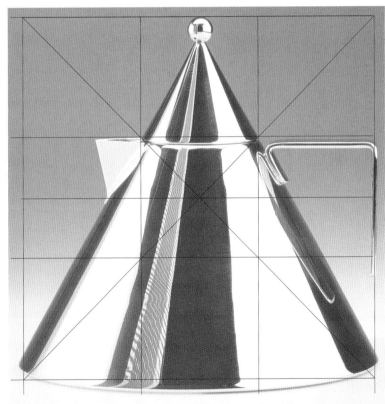

133

Volkswagen Beetle, Jay Mays, Freeman Thomas, Peter Schreyer, 1997

The new Volkswagen Beetle is less a vehicle and more a piece of kinetic sculpture as it moves down the road. Distinctly different from other cars, it eloquently captures the visual idea of cohesiveness of form. The body is both part retro and part futuristic, a fusion of geometry and nostalgia.

The body fits neatly into the top half of a golden ellipse. The side windows repeat the shape of the golden ellipse, with the door resting in the square of the golden section rectangle, and the rear window in the reciprocal golden rectangle. All of the details of changes in surfaces are tangent golden ellipses or circles. Even the placement of the antenna is at an angle tangent to the front wheel well.

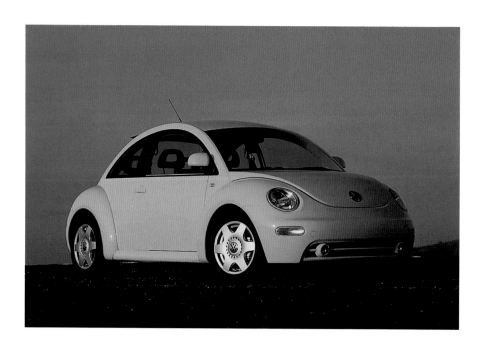

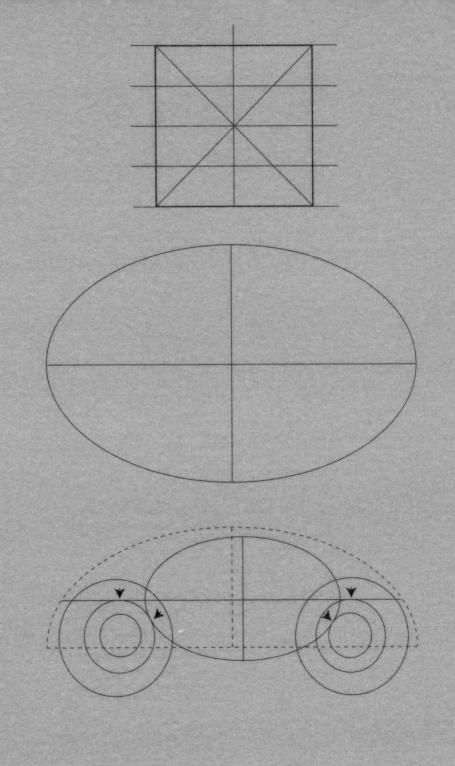

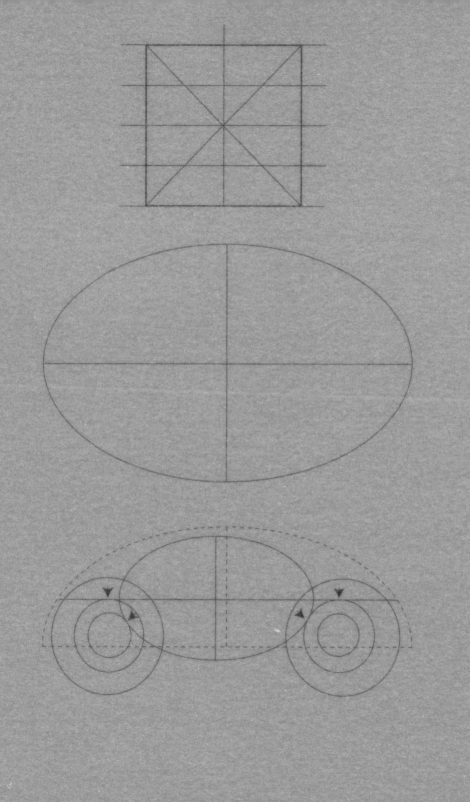

Front View

The front of the car is almost square with all surfaces symmetrical. The Volkswagen logo on the hood is at the center of the square.

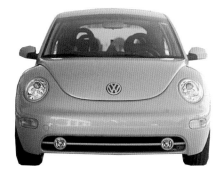

Analysis

A golden ellipse is inscribed in a golden rect-angle construction dia-gram. The body fits clean-ly in the top half of this golden ellipse. The major axis of the ellipse aligns with the body just below the center of the tires. (below) A second golden ellipse encloses the side windows. This ellipse is also tangent to the front wheel well and tangent to the rear wheel. The major axis of the ellipse is tan-gent to both the front and rear wheel wells.

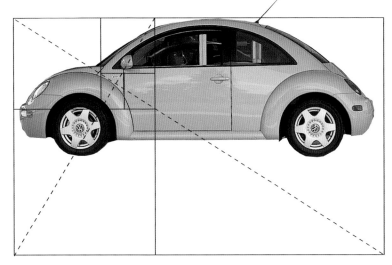

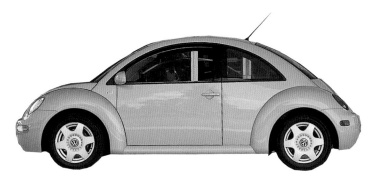

Rear View

Like the front view, the rear view can fit into a square. Again, the logo is near the center point of the square, and all elements and surface changes are symmetrical. The geometry of the car body is also carried through to other details. The headlights and rear lights are ellipses but because they rest on curved surfaces they appear to be circles. Even the door handle is a debossed circle that is bisected by a radiused rectangle with a circular door lock.

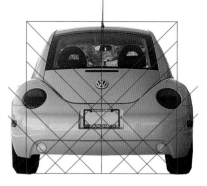

Antenna

The angle of the antenna is tangent to the circle of the front wheel well and the position of the antenna base is aligned with the rear wheel fender.

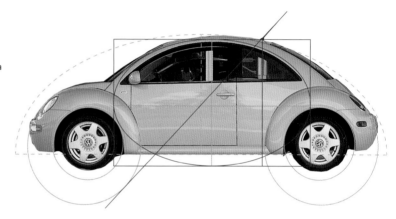

Postscript

Le Corbusier in *The Modulor*, 1949:

"The regulating lines are not, in principle, a preconceived plan; they are chosen in a particular form depending on the demands of the composition itself, already formulated, already well and truly in existence. The lines do no more than establish order and clarity on the level of geometrical equilibrium, achieving or claiming to achieve a veritable purification. The regulating lines do not bring in any poetic or lyrical ideas; they do not inspire the theme of the work; they are not creative; they merely establish a balance. A matter of plasticity, pure and simple."

Le Corbusier was correct. Geometric organization in and of itself does not yield the dynamic concept or inspiration. What it does offer to the creative idea is a process of composition, a means of interrelationship of form, and a method for achieving visual balance. A system of bringing the elements together into a cohesive whole.

Although Le Corbusier wrote of the intuitive in geometric organization, my research has shown that in design and architecture it is far less intuitive and far more often a result of knowledge that is thoughtfully applied. Many of the artists, designers, and architects whose work is analyzed in *Geometry of Design* have written about the relationship of geometry to their work. Those involved in education considered geometric organization and planning essential and fundamental to the design process.

Architecture has some of the strongest educational ties to geometric organization because of the necessity for order and efficiency in construction, and the desire to create aesthetically pleasing structures. The same is not true of art and design. In many schools of art and design the study of geometric organization begins and ends with a discussion of the golden section relationship to the Parthenon in an art history course. This is due in part to the separation of information that is a part of education. Biology, geometry, and art are taught as separate subjects. The content congruencies are often neglected and the student is left to make the connections. In addition, because art and design are commonly viewed as intuitive endeavors and expressions of personal inspiration, few educators will bring biology or geometry into the studio, or art and design into the science or math classroom. *Geometry of Design* is the result of my efforts to bring some of the congruencies among design, geometry, and biology to my graphic design students.

Kimberly Elam

Acknowledgements

Editorial Services
Christopher R. Elam

Mathematics Editor
Dr. David Mullins, Associate Professor of Mathematics, New College of the University of South Florida

Special Thanks To:
Mary R. Elam

Johnette Isham, Ringling College of Art and Design

Jeff Maden, Suncoast Porsche, Audi, Volkswagen, Sarasota, Florida

Peter Megert, Visual Syntax Design, Columbus, Ohio

Allen Novak, Ringling College of Art and Design

Jim Skinner, Sarasota, Florida

Jennifer Thompson, Editor, Princeton Architectural Press

Peggy Williama, Conchologist, Sarasota, Florida

Credits:
The analysis of Bruno Monguzzi's Majakovskij poster is based on an original analysis by Anna E. Cornett, Ringling College of Art and Design.

The analysis of Jules Chéret's Folies-Bergère is based on an original analysis by Tim Lawn, Ringling College of Art and Design.

138

Credits

Argyle Chair (302), Charles Rennie Mackintosh, Cassina I Maestri Collection

Ball at the Moulin Rouge, Henri de Toulouse-Lautrec, Dover Publications, *120 Great Impressionist Paintings*

Barcelona Chair, Ludwig Mies van der Rohe, Courtesy of Knoll Inc.

Barrel Chair, 1903, Biff Henrich/ Keystone Film

Barrel Chair, Courtesy of Copeland Furniture

Barrel Chair, Frank Lloyd Wright, Cassina I Maestri Collection

Bathers at Asnières, Georges-Pierre Seurat, Dover Publications, *120 Great Impressionist Paintings*

Braun Handblender, Courtesy of Braun

Brno Chair, Ludwig Mies van der Rohe, Courtesy of Knoll Inc.

Chaise Longue, Le Corbusier (Charles Edouard Jeanneret), 1929, Courtesy of Cassina USA

Der Berufsphotograph, Jan Tschichold, Collection of Merrill C. Berman

Doryphoros (The Spear-Bearer), Roman copy, Jack S. Blanton Museum of Art, The University of Texas at Austin, The William J. Battle collection of Plaster Casts. Photo: Frank Armstrong and Bill Kennedy

Eames Molded Plywood Chair, Charles Eames & Eero Saarinen, Courtesy Herman Miller, Inc., Photo by Phil Schaafsma

East Coast by L.N.E.R., Tom Purvis, Collection of the Victoria & Albert Museum

Farnsworth House elevation, Courtesy of the Farnsworth House/National Trust for Historic Preservation

Farnsworth House photograph, Courtesy Steven F. Shundich, 16 November, 2008

Fechner Tables & Graphs, The Divine Proportion: A Study In Mathematical Beauty, H. E. Huntley, Dover Publications, 1970

Furstenberg Porzellan Poster, Inge Druckery

Ghent, Evening, Albert Baertsoen, Dover Publications, *120 Great Impressionist Paintings*

Hill House Chair (292), Charles Rennie Mackintosh, Cassina I Maestri Collection

Human Figure in a Circle, Illustrating Proportions, Leonardo da Vinci, *Leonardo Drawings*, Dover Publications, Inc., 1980

Il Conico Kettle, Aldo Rossi, 1986, Produced by Alessi s.p.a.

Illinois Institute of Technology Chapel, Photographer – Hedrich Blessing, Courtesy of the Chicago Historical Society

Iron Rocker, Courtesy of Rita Bucheit, RitaBucheit.com

Job Poster, Folies-Bergère Poster, *The Posters of Jules Chéret*, Lucy Broido, Dover Publications, Inc., 1992

Johnson Glass House elevations and plans, Courtesy of Philip Johnson Glass House/National Trust for Historic Preservation

Johnson Glass House photograph, Anne Dunne

Konstruktivisten, Jan Tschichold, Collection of Merrill C. Berman

La Goulue Arriving at the Moulin Rouge with Two Women, Henri de Toulouse-Lautrec, Dover Publications, *120 Great Impressionist Paintings*

LEB Identity, Courtesy of Marion Wessel-Henrion and the University of Brighton Design Archives, www.brighton.ac.uk/designarchives

L'Intransigéant, A. M. Cassandre, Collection of Merrill C. Berman

Man Inscribed in a Circle (after 1521), *The Human Figure by Albrecht Dürer, The Complete Dresden Sketchbook*, Dover Publications, Inc., 1972

MR Chair, Courtesy of Knoll Inc.

Otl Aicher Pictograms © 1976 by ERCO GmbH, www.aicher-pictograms.com

Pine Cone Photograph, *Shell* Photographs, *Braun Coffeemaker* Photograph, Allen Novak

Poseidon of Artemision, Photo courtesy of the Greek Ministry of Culture

Racehorses at Longchamp, Edgar Degas, Dover Publications, *120 Degas Paintings and Drawings*

S. C. Johnson Desk and Chair vintage photograph, Courtesy of Steelcase Inc.

S. C. Johnson Three-Legged Chair photograph, Courtesy of S. C. Johnson & Son Inc.

S. C. Johnson Wax 1 Desk (617), Frank Lloyd Wright, Cassina I Maestri Collection

S. C. Johnson Wax 2 Chair (618), Frank Lloyd Wright, Cassina I Maestri Collection

Staatliches Bauhaus Austellung, Fritz Schleifer, Collection of Merrill C. Berman

Tauromaquia 20, Goya, Dover Publications, *Great Goya Etchings: The Proverbs, The Tauromaquia and The Bulls of Bordeaux Francisco Goya*, Philip Hofer

Thonet Bentwood Chair #14, Dover Publications, *Thonet Bentwood & Other Furniture, The 1904 Illustrated Catalogue*

Thonet Bentwood Rocker, Dover Publications, *Thonet Bentwood & Other Furniture, The 1904 Illustrated Catalogue*

Tulip Chair, Eero Saarinen, Courtesy of Knoll Inc.

Vanna Venturi House, Courtesy of Venturi, Scott Brown and Associates, Inc. Photograph by Rollin LaFrance for Venturi, Scott Brown and Associates, Inc.

Volkswagen New Beetle, Courtesy of Volkswagen of America, Inc.

Wagon-Bar, A. M. Cassandre, Collection of Merrill C. Berman

Wassily Chair, Courtesy of Knoll Inc.

Willow Chair (312), Charles Rennie Mackintosh, Cassina I Maestri Collection

139

Selected Bibliography

Alessi Art and Poetry, Fay Sweet, Ivy Press, 1998

A.M. Cassandre, Henri Mouron, Rizzoli International Publications, 1985

Art and Geometry, A Study In Space Intuitions, William M. Ivins, Jr., Dover Publications, Inc., 1964

Basic Visual Concepts and Principles for Artists, Architects, and Designers, Charles Wallschlaeger, Cynthia Busic-Snyder, Wm. C. Brown Publishers, 1992

Contemporary Classics, Furniture of the Masters, Charles D. Gandy A.S.I.D., Susan Zimmermann-Stidham, McGraw-Hill Inc., 1982

The Curves of Life, Theodore Andrea Cook, Dover Publications, Inc., 1979

The Divine Proportion: A Study In Mathematical Beauty, H.E. Huntley, Dover Publications, Inc.,1970

The Elements of Typographic Style, Robert Bringhurst, Hartley & Marks, 1996

50 Years Swiss Poster: 1941-1990, Swiss Poster Advertising Company, 1991

The Form of the Book: Essays on the Morality of Good Design, Jan Tschichold, Hartley & Marks, 1991

The Geometry of Art and Line, Matila Ghyka, Dover Publications, Inc., 1977

The Graphic Artist and His Design Problems, Josef Müller-Brockmann, Arthur Niggli Ltd., 1968

Grid Systems in Graphic Design, Josef Müller-Brockmann, Arthur Niggli Ltd., Publishers, 1981

The Golden Age of the Poster, Hayward and Blanche Cirker, Dover Publications, Inc., 1971

A History of Graphic Design, Philip B. Meggs, John Wiley & Sons, 1998

The Human Figure by Albrecht Dürer, The Complete Dresden Sketchbook, Edited by Walter L. Strauss, Dover Publications, Inc.,1972

Josef Müller-Brockmann, Pioneer of Swiss Graphic Design, Edited by Lars Müller, Verlag Lars Müller, 1995

Leonardo Drawings, Dover Publications, Inc., 1980

Ludwig Mies van der Rohe, Arthur Drexler, George Braziller, Inc., 1960

Mathographics, Robert Dixon, Dover Publications, Inc., 1991

Mies van der Rohe: A Critical Biography, Franz Schulze, The University of Chicago Press, 1985

The Modern American Poster, J. Stewart Johnson, The Museum of Modern Art, 1983

The Modern Poster, Stuart Wrede, The Museum of Modern Art, 1988

The Modulor 1 & 2, Le Corbusier, Charles Edouard Jeanneret, Harvard University Press, 1954

The Posters of Jules Chéret, Lucy Broido, Dover Publications, Inc., 1980

The Power of Limits: Proportional Harmonies in Nature, Art, and Architecture, Gyorgy Doczi, Shambala Publications, Inc., 1981

Sacred Geometry, Robert Lawlor, Thames and Hudson, 1989

Thonet Bentwood & Other Furniture, The 1904 Illustrated Catalogue, Dover Publications, Inc., 1980

The 20th-Century Poster - Design of the Avant-Garde, Dawn Ades, Abbeville Press, 1984

20th Century Type Remix, Lewis Blackwell, Gingko Press, 1998

Towards A New Architecture, Le Corbusier, Dover Publications, Inc., 1986

Typographic Communications Today, Edward M. Gottschall, The International Typeface Corporation, 1989

Index

143